Artur Landt

Nikon N60/F60

Magic Lantern Guides

Nikon

N60 · **F60**

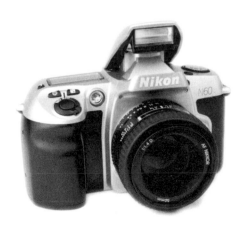

Artur Landt

Magic Lantern Guide to
Nikon N60/F60

Published in the United States of America by

Silver Pixel Press®
A Tiffen® Company
21 Jet View Drive
Rochester, NY 14624
Fax: (716) 328-5078

From the German edition *Nikon F60* by Artur Landt
Translated by Hayley Ohlig
Printed in Germany by Kösel GmbH, Kempten

©1998 Verlag Georg D.W. Callwey GmbH & Co.
Munich, Germany

©1999 English language edition, Silver Pixel Press

Library of Congress Cataloging-in-Publication Data
Landt, Artur, 1958–
 [Nikon F60. English]
 Nikon N60/F60 / Artur Landt. -- English language ed.
 p. cm. -- (Magic lantern guides)
 ISBN 1-883403-56-1
 1. Nikon camera--Handbooks, manuals, etc. I. Title. II. Series.
TR263.N5L36 1999
771.3'1--dc21 99-10123
 CIP

This book is not sponsored by Nikon, Inc. Information, data, and procedures are correct to the best of the publisher's knowledge; all other liability is expressly disclaimed. Because specifications may be changed by the manufacturer without notice, the contents of the book may not necessarily agree with changes made after publication. Product photos provided by Nikon GmbH. All creative photography is by Artur Landt, unless otherwise noted.

Contents

Foreword

This *Magic Lantern Guide to the Nikon N60/F60* will instruct you in how to use all the features of your Nikon camera to their fullest advantage. (This camera is designated as the Nikon N60 in markets within the United States and as the Nikon F60 in other markets.) Inside you'll find step-by-step instructions in clear, easy-to-understand language telling you everything you need to know about your camera and its functions.

This book will also take you into the challenging world of single-lens-reflex (SLR) photography, providing you with detailed information on lenses and accessories that are compatible with your camera. Selecting an appropriate focal length lens gives you the control you need to convert your visions into beautiful pictures. When combined with Nikon's extensive system of lenses, flash units, and accessories, the N60/F60 offers a world of opportunities for you to create successful professional-quality photographs.

Introduction

The versatile Nikon N60/F60 is designed to meet the needs of anyone interested in capturing great photos. This innovative Nikon camera offers ten exposure modes, identified by symbols on the exposure mode dial. It features five subject programs (called Vari-Programs) to take portraits, landscapes, close-ups, sports, and night scenes in addition to two automatic Program modes (General-Purpose Program and Auto-Multi Program). Aperture-Priority mode, Shutter-Priority mode, and fully Manual mode are available for those photographers who prefer to select the aperture and shutter speed themselves. The camera also has a Flexible Program (Program Shift) function, which allows you to change the shutter speed-aperture combination in Auto-Multi Program mode while maintaining an equivalent exposure value.

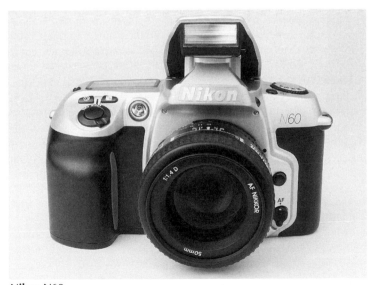

Nikon N60

The Nikon N60/F60 has two exposure metering methods: 3D matrix metering and center-weighted metering. 3D matrix metering, an enhanced form of 6-segment matrix metering, is available with Nikkor D, AF-S, and AF-I lenses and AF-I teleconverters. With non-D AF and AI-P Nikkor lenses mounted, six-segment matrix metering is utilized instead. Nikon's matrix metering system divides the entire viewfinder into six metering fields, each of which is metered individually, and the results are combined to calculate exposure. 3D matrix metering utilizes information derived from the six-segment matrix metering system and combines it with the distance information derived from the lens. The results are analyzed by the camera's computer to determine subject contrast and the distribution of illumination within the scene. With center-weighted average metering, 75 percent of the emphasis is placed on the central 12mm area of the viewfinder image, and the remaining viewing area is weighted 25 percent in the exposure calculation.

The camera's autofocus (AF) system automatically selects one of two autofocus modes depending on the subject and the exposure program in use. The camera's Auto-Servo AF default setting is Single-Servo AF with focus priority, which is ideal for shooting stationary subjects. However, as soon as the AF sensor notices subject movement, the camera's computer automatically switches to Continuous-Servo AF with focus tracking. In Sport mode the camera always uses Continuous-Servo AF.

The Nikon N60/F60 boasts a very powerful TTL flash exposure system, which works with the built-in flash or any Nikon Speedlight. The matrix-controlled TTL exposure metering system ensures an effective balance between daylight and flash illumination. The Nikon N60/F60's built-in, pop-up flash unit is very powerful for its size with a guide number of 49 in feet (15 in meters) at ISO 100.

Nikon also makes a quartz date version of the N60/F60 called the N60QD. With this model, you can imprint data on the film frame if desired (see page 24 for more information).

This short introduction gives you an idea of the Nikon N60/F60's extensive range of functions and the limitless possibilities it offers you.

Basic Photographic Terms

To help you better understand your camera and this guide, we've included some definitions of the basic terms you'll find in this book.

AF: Autofocus; automatic, motorized focus control.

Auto-Servo AF: Automatic focusing system that shifts from locking focus on a static subject to predictive AF with focus tracking as soon as the AF sensor registers subject movement.

Center-Weighted Average Metering: Through-the-lens metering in which the central 12mm area in the viewfinder is weighted heavily in determining exposure.

Continuous-Servo AF: Focus follows the subject's motion, as long as the shutter release is pressed partway.

EV: Exposure value; a numeric designation describing the range of shutter speed-aperture combinations that will produce the same exposure effect for a given film sensitivity and at a given brightness. For example, the following shutter speed-aperture combinations all produce the same exposure: 1/250 second at f/2 = 1/125 second at f/2.8 = 1/60 second at f/4 = 1/30 second at f/5.6 = 1/15 second at f/8. With ISO 100 film and under identical lighting conditions, they all have an EV of 10.

Focus Priority: The shutter does not release unless focus is achieved.

Release Priority: The shutter releases when the shutter release button is pressed fully, regardless of whether focus has been achieved.

Single-Servo AF: Focus is locked on the subject when the shutter release is pressed partway. It functions with focus priority. Ideally suited for stationary subjects.

Six-Segment Matrix Metering: TTL metering in which the illumination of multiple metering segments is evaluated.

SLR: Single lens reflex; refers to a camera design in which the image that travels through the lens is transmitted to the viewfinder by a mirror; the image that one sees in the viewfinder is the image that is recorded on film.

3D Matrix Metering: TTL metering in which the illumination of multiple metering segments is evaluated in conjunction with the subject's distance.

TTL: Through-the-Lens, internal metering; the camera meters the light entering through the lens.

Understanding the Nikon N60/F60's Controls

User-Friendly Design

The N60/F60 is the first electronically based Nikon camera to be designed with an exposure mode dial. This dial is the control that opens the door to the camera's myriad operational functions. This return to an analog style seems to be the latest trend in camera design, as design engineers have recognized that the exposure mode dial is preferred by photographers due to its ease of use and versatility in selecting important camera functions. Practically speaking, there is simply nothing better than a dial for fast operation. The mode symbols are clearly printed on the exposure mode dial and can be seen easily at a glance, even with the camera turned off. All the other camera controls are clearly marked on the camera body and are located exactly where one would naturally look for them.

The camera's ergonomic design features function buttons and controls exactly where one would expect to find them.

Note: Throughout this book the terms "left" and "right" are used to describe the locations of the camera controls assuming that the camera is being held in the shooting position.

Camera Controls

The Nikon N60/F60's functions are accessed with controls that are clearly marked, which makes the camera very easy to use. What follows is a brief introduction to each of the controls.

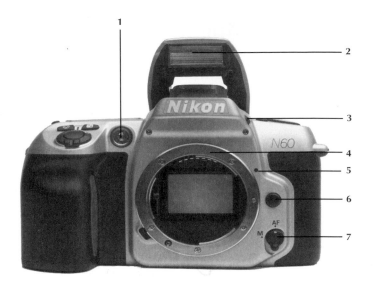

1. AF-assist illuminator/Self-
 timer/Red-eye reduction lamp
2. Built-in flash
3. Flash lock release button

4. Lens mount
5. Lens mounting index
6. Lens release button
7. Focus mode selector

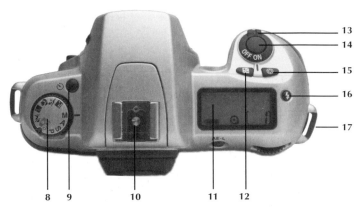

8. Exposure mode dial
9. Self-timer button
10. Accessory hot shoe
11. LCD panel
12. Exposure compensation button

13. Main switch
14. Shutter release button
15. Aperture button
16. Flash sync mode button
17. Camera strap eyelet

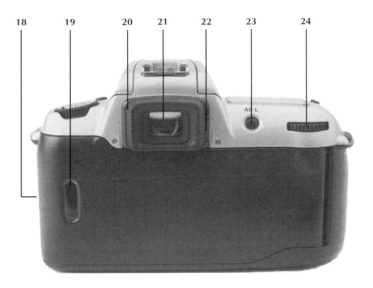

18. Camera back lock release
19. Film window
20. Rubber eyecup
21. Finder eyepiece

22. Diopter adjustment lever
23. AE-L button
24. Command dial

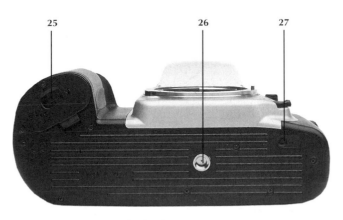

25. Battery chamber cover lock release
26. Tripod socket
27. Mid-roll rewind button

Main Switch

The N60/F60's main power switch is located on top of the hand grip, surrounding the shutter release. This switch turns the camera on and off.

Shutter Release Button

The shutter release button is located on top of the hand grip, in the center of the main switch. Lightly pressing it activates the autofocus system and the exposure meter. These systems shut down 5 seconds after pressure has been lifted. Once focus has been achieved (the focus indicator at the bottom left of the viewfinder glows steadily) focus is locked if light pressure is maintained on the shutter release. This allows you to maintain focus on the subject while recomposing the image so that the subject is not in the center of the frame. Exposure occurs when the shutter release is pressed all the way down.

Exposure Mode Dial

The exposure mode dial is on the left side of the top of the camera. It is printed with symbols of each of the camera's exposure modes: General-Purpose Program (green Auto), Auto-Multi Program (P), Shutter-Priority (S), Aperture-Priority (A), Manual (M), Night Scene, Sport, Close-up, Landscape, and Portrait. The exposure mode dial makes it easy to select a mode quickly, and you can see which mode is selected even when the camera is turned off.

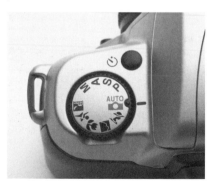

The N60/F60's exposure mode dial makes selecting an exposure mode easy. Turn the dial and align the symbol for the desired mode with the index on the camera.

Command Dial

The command dial is located directly below and to the right of the LCD panel and is controlled by the right thumb. With this dial you can use the camera's Flexible Program (Program Shift) function in Auto-Multi Program (P) mode; turning the command dial shifts the exposure settings to a different but equivalent exposure. In Aperture-Priority (A) mode turning the command dial sets the aperture, and in Shutter-Priority (S) and Manual (M) exposure modes it sets the shutter speed. In Manual mode the aperture is set by turning this dial while simultaneously pressing the aperture button. Exposure compensation is set by turning the command dial while pressing the exposure compensation (+/–) button at the same time.

Autoexposure Lock (AE-L) Button

Located to the left of the command dial, the AE-L button allows you to lock the exposure settings without locking the focus. This means that you can lock exposure on one area of a scene and later press the shutter release lightly to lock focus on another. When the AE-L button is used, center-weighted average metering is automatically activated. (See page 60 for more information.)

Aperture Button

The aperture button is located on the top of the camera, behind and to the right of the shutter release button. Pressing this button and turning the command dial sets the aperture in Manual (M) mode. (See page 89 for more information.)

Exposure Compensation Button

The exposure compensation (+/–) button is located on the top of the camera, behind and to the left of the shutter release button. Pressing this button while turning the command dial selects exposure compensation in 1/2-stop increments in a range of +/–3 EV in Auto-Multi Program (P), Shutter-Priority (S), Aperture-Priority (A), and Manual (M) mode. (See page 60 for more information.)

Flash Sync Mode Button

Pressing the flash sync mode button (located to the right of the LCD panel and marked with a lightning bolt) while turning the command dial allows you to select flash modes: normal sync, red-eye reduction, slow sync, and red-eye reduction with slow sync, depending on the exposure mode you have selected. (See page 158 for more information.)

Flash Lock Release Button

The flash lock release button located to the left of the camera's prism pops the built-in flash up, making it ready to fire when the shutter is released.

Self-Timer Button

The self-timer button is located in front of the exposure mode dial and is labeled with a clock symbol. Pressing this button readies the camera for a self-timed exposure, however countdown does not begin until the shutter release is pressed. The countdown can be interrupted and canceled by pressing the self-timer button a second time. Other methods of canceling the self-timer function are turning off the main switch, performing two-button reset (see page 41), or leaving the camera dormant for more than 30 seconds. (See page 38 for more information.)

Lens Release Button

The lens release button is located next to the bayonet mount at three o'clock as you face the camera. Press this button to unlock the lens from the bayonet mount so you can take it off the camera. It is not necessary to press the lens release button to mount a lens to the camera. (See page 29 for more information.)

Focus Mode Selector

The focus mode selector is located on the left front of the camera, beside the camera's bayonet. With it you can select manual (M) or automatic (AF) focus. (See page 44 for more information.)

Diopter Adjustment Lever

The diopter adjustment lever is used to adjust the eyepiece to the photographer's eyesight. The camera's diopter can be adjusted between −1.5 and +1.0 diopters. (See page 31 for more information.)

Mid-Roll Rewind Button

The small button on the left of the camera's base allows you to rewind the film before the end of the roll has been reached. When this is done, the film leader is retracted completely into the cassette, so if you later wish to reload and expose the rest of the roll, a film leader retriever is required to pull the leader out. (See page 34 for more information.)

Camera Back Lock Release

Pushing down (in the direction of the arrow) on the switch located on the left side of the body unlocks and opens the camera's back so you can load and unload film. (See page 32 for more information.)

Battery Chamber Cover Lock Release

To open the battery chamber, slide the battery chamber lock release lever in the direction of its arrow. The chamber lid will pop open. (See page 27 for more information.)

Information Displays

Viewfinder Display

The viewfinder is the N60/F60's internal information center. The locations of the AF sensor and the 12mm center-weighted metering area are etched on the ground glass. Not only can you determine if the subject is in focus by looking through the viewfinder, but you can also see all exposure-relevant data at a glance at the base of the viewfinder. The black dot on the far left of the row is the in-focus indicator. Listed next are the shutter speed and aperture settings. The analog scale on the right displays the exposure compensation setting in P, S, and A mode or the exposure variance in M mode. If the exposure

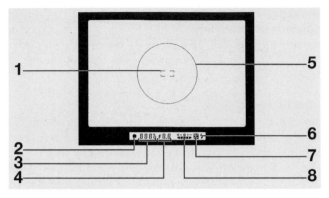

1. Focus brackets
2. Focus indicator
3. Shutter speed
4. Aperture
5. Center-weighted metering area
6. Flash ready light
7. Exposure compensation symbol
8. Exposure compensation/Underexposure-Overexposure scale

compensation symbol is visible, exposure compensation has been entered. The flash ready light (lightning bolt) on the far right indicates flash status: If the built-in or accessory flash unit is off, the ready light blinks to indicate that flash is recommended; if the Speedlight is turned on, it illuminates when the flash is ready to fire; and once the flash has fired, it blinks if the flash burst was insufficient for proper exposure.

LCD Panel

The LCD (Liquid Crystal Display) panel is the Nikon N60/F60's complete control and information display center. It informs the photographer about the camera settings and offers information about battery condition and the number of frames that have been shot. The illustration shows all displays simultaneously, however only active data and functions appear during normal operation. The top row, from left to right, displays: Flexible Program (P*), also known as Program Shift; shutter speed; and aperture. Below that are the indicators for flash modes, battery condition, self-timer, exposure compensation value, film status, and frame counter.

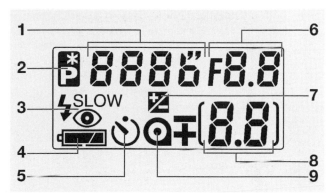

1. Shutter speed
2. Flexible Program
3. Flash sync mode
4. Battery indicator
5. Self-timer indicator
6. Aperture
7. Exposure compensation
8. Frame counter/Exposure compensation value
9. Film loaded indicator

The LCD uses liquid crystals to display the information. At temperatures around 140° F (60° C), which can easily be attained in a car parked in the sun, the display turns completely black. Very low temperatures (around freezing) cause the liquid crystals to react somewhat slowly. The crystals recover from temperature-induced failure on their own as soon as the temperature returns to normal, around 68° F (20° C).

Test the Controls Before You Get Started

We strongly recommend that if you have had little or no experience with an autofocus SLR camera, you should do a dry run to test all the N60/F60's controls without a roll of film loaded. This may use up a little battery power, but in the long run, it will significantly reduce the amount of film you might waste on experimentation. Try turning all camera functions on and off, autofocus on various subjects at various distances, focus manually, experiment with locking exposure and locking focus

separately, and activate the built-in flash in a variety of lighting situations. In particular, practice locking focus on an off-center subject by aiming on the subject, pressing the shutter release lightly, and recomposing the frame. Getting the feel of the half-pressed shutter release is crucial to getting to know how to operate this camera without misfiring. An hour spent experimenting with your camera will be well worth it when you spot the picture you really want to take.

Nikon N60QD

The Nikon N60/F60 is available in a date back model called the Nikon N60QD (Quartz Date). With this model you can expose the date and time onto the frame if desired. The imprinting options are: year/month/day, day/hour/minute, month/day/year, or day/month/year. It automatically makes adjustments for leap years through the year 2019.

The data are printed in the lower right-hand corner of a horizontal image. With vertical pictures taken holding the camera's grip at the top, the data are imprinted in the top right-hand corner, which usually ruins the image. When composing a shot with the intention of adding data to it, be aware that the imprinted data are hard to read on a light or reddish background. The data can remind you when an event took place, but having numbers floating in the corner of an image can also ruin a good shot. One solution is to sacrifice a frame by exposing the date onto it before you take the actual photograph. This makes it easier to reconstruct the sequence of events in your vacation later. Exposing data onto a frame is ideally suited for documentation in science and research. Even test shots can be identified in this manner. In creative photography, however, data imprinting distracts from the impact of the photo more often than not.

This camera model uses only DX-coded film with an ISO of 32 to 3200. It is powered by a single 3-volt CR2025 (or equivalent) lithium battery and comes in a black finish.

Setting the Date Back

There are three buttons under the date back's control panel labeled MODE, SELECT, and ADJUST. Pressing MODE activates the control panel. Each time MODE is pressed, a different data combination is displayed (year/month/day, month/day/year, day/month/year, day/hour/minute). When the desired data combination appears, press the SELECT button. To set the correct information: date, time, year, etc., press the ADJUST button. You can cycle through the settings quickly by pressing the ADJUST button down and holding it. Once you arrive at the desired setting, lift your finger from the button and lock the setting in by pressing the SELECT button again. After all the data are selected and entered, the desired combination can be chosen by pressing the SELECT button. If you do not want data to appear, press SELECT until "- - - - - -" is visible on the date back's LCD panel.

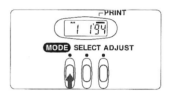

The date back is designed to make it easy to set the data you want imprinted on your photos.

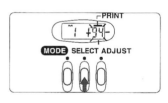

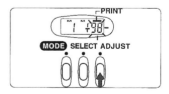

25

Preparing to Use the N60/F60

Now that you're familiar with the N60/F60's controls and displays, there are a few basics you'll need to know before you can start shooting pictures with your camera, such as how to attach the strap, mount a lens, and how to load batteries and film. Knowing how to do these things correctly is very important to preventing errors and frustration and to increasing your enjoyment of the N60/F60. Incorrectly installed batteries, an improperly attached strap, a poorly adjusted eyepiece, and an improperly mounted lens can all adversely affect your camera's performance. This chapter will help you learn how to avoid these pitfalls.

Attaching the Camera Strap

If you purchased your N60/F60 new, the first thing you should do after unpacking it is attach the camera strap that comes with it. This item not only protects the camera from inadvertently dropping to the ground, it also makes the camera easier to carry and faster to fire. Changing lenses and film is also much faster and more secure if the camera is hung around your neck or shoulder.

Begin by feeding one end of the strap through the eyelet on the left shoulder of the camera from the bottom up. The tip of the

The Nikon N60/F60 is lightweight and comfortable to hold.

strap should be on the "inside" (camera side), beside the exposure mode dial. Position the plastic sliding fastener on the strap so that there is at least 1 inch (2.5 cm) of strap between it and the eyelet. Now feed the tip of the strap back up through the two holes on the plastic slider, following the path of the already threaded strap. Repeat

this procedure by feeding the other end of the strap through the eyelet on the right side of the camera and through the other plastic slider. Before pulling the strap tightly through the sliders, make sure that the strap is not twisted and that its length sets the camera at an appropriate position when hanging around your neck or on your shoulder. Finally, tighten the strap.

Attach a shoulder strap to your camera before using it.

Loading Batteries

Two 3-volt CR123A or equivalent lithium batteries are required to power your Nikon N60/F60. There are a few important guidelines to follow when it comes to installing batteries. First, turn the camera's main switch to OFF when changing the batteries. Both batteries you install should be made by the same manufacturer. Never install a combination of old and new batteries in your camera. Make sure that the contacts in the battery chamber and on the batteries are clean, dry, and not greasy. If necessary, wipe them off with a soft cloth before installation to ensure an optimal flow of current.

The N60/F60's battery compartment is located in the camera's hand grip. To open the battery compartment, slide the battery chamber lock release down in the direction of its arrow. The

compartment door will pop open, revealing + and − symbols engraved on its inner face. After inserting the batteries, close the door by pressing it gently until it clicks shut.

Checking the Batteries

When the camera's main switch is turned on, a battery symbol indicating the condition of the batteries appears in the lower left-hand corner of the LCD panel. (It does not matter in which position the exposure mode dial is set.) This symbol is displayed until the camera is turned off. The battery symbol shows the batteries' power level in three increments. An all-black symbol indicates a full or acceptable charge. As the batteries'

Batteries are installed in the battery compartment in the camera's hand grip. Make sure that the polarity of the batteries matches the polarity guides engraved on the compartment cover.

charge decreases, only a half of the symbol is black. At this point, you do not have to replace the batteries, but it would be wise to purchase a spare set. Batteries that cause a half-black symbol to be displayed can sometimes "recover" and display a

full-charge symbol the next time the camera is turned on. This is due in part to fluctuations in the batteries' charge as well as to the camera's programming for that symbol, which is set to indicate a drop in power very early. Batteries should be replaced when the half-black battery symbol begins to flash. If no battery symbol appears on the monitor after the batteries are replaced, they may have been installed incorrectly. If this occurs, try reloading the batteries.

About Lithium Batteries

Lithium batteries have excellent performance characteristics such as high load capacity, excellent temperature tolerance, and a flat

discharge curve over almost their entire life. Thanks to their minimal spontaneous discharge, lithium cells can be stored for up to 10 years. But even a lithium battery can "fall asleep" if it is not used for an extended period of time. Before using a battery that has lain dormant for over a year, you need to first "wake it up." This is called "conditioning" and it is done by firing 10 to 15 flash shots within a short period without film in the camera. Should the camera's flash get too hot during this operation, its safety circuit will kick in. There is no danger to the unit itself.

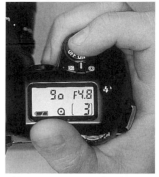

If batteries are installed and the camera is turned on, the battery symbol is displayed on the LCD panel.

Mounting and Removing a Lens

Attaching and removing lenses on the Nikon N60/F60 is very simple but must nevertheless be done carefully. Lenses can be attached or removed with or without film in the camera and regardless of the aperture, focus, or zoom settings. We recommend that you change lenses out of direct sunlight (in the shade of your body) and with the camera hanging securely around your neck or over your shoulder.

Note: The translucent body cap that comes with the camera has little gripping power and comes off very easily. We recommend replacing it with the Nikon BF-1A body cap accessory. Unlike the cap that comes with the camera, the black BF-1A cap locks into the camera's bayonet so that it cannot slip off during transport. The BF-1A is available through Nikon-authorized photo dealers.

First, remove both the body cap and the lens' rear cap. With the camera's main switch turned off, grip the lens' knurled aperture ring, and place the lens on the camera so that the aperture/distance index (the wide white line in the middle of the

29

lens) aligns with the dot next to the camera's bayonet (at two o'clock as you face the camera). Now turn the lens counter-

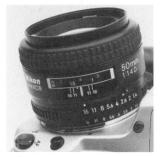

clockwise until it stops and clicks into place. To make sure that it is properly locked, try gently turning the lens clockwise (the lens should not move at all).

Caution: *When the lens is turned into the mount, the electrical contracts brush past one another. Turning the camera off while mounting a lens can prevent erroneous and potentially damaging electrical signals from being passed between the lens and the camera.*

When mounting a lens, the white line in the center of the lens must first be aligned with the index next to the lens mount.

To remove the lens, press the lens release button (located at three o'clock as you face the camera) and turn the lens clockwise. Immediately mount another lens or a body cap in its place and put a rear lens cap on the lens you've just removed.

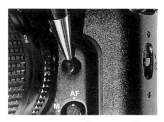

To remove the lens, press the lens release button, turn it clockwise, and lift it off the camera.

If the lens is not mounted properly and the main switch is turned on, the aperture displays on the LCD panel and viewfinder flash "F--," and the shutter release locks. If this occurs, turn the camera off and remount the lens correctly. This also occurs when non-CPU (non-AF) lenses are mounted to the N60/F60. However, there is a solution: Setting the exposure mode to Manual unlocks the shutter release and allows you to shoot with the lens.

The smallest aperture on the lens must be set for electronic autoexposure information to be passed from lens to camera.

Setting the Lens to Its Smallest Aperture

In every mode, the lens must be set at its minimum aperture for the automatic exposure information to be transferred to the camera. The minimum aperture (the largest number, engraved in orange) on the aperture ring must be aligned opposite the lens' aperture/distance index. To lock the lens at its minimum aperture, the minimum aperture lock switch must be slid to the orange dot. If the lens is not set at its smallest aperture, the "FEE" error message flashes in the viewfinder and LCD panel, and the shutter release locks, preventing exposure.

Diopter Adjustment

A clear viewfinder image is important for image composition and manual focusing. To ensure that everyone, even photographers with imperfect eyesight, can see a sharp viewfinder image, the Nikon N60/F60 comes with a diopter adjustment lever. The camera's built-in correction range covers –1.5 to +1.0 diopters, however Nikon offers nine accessory diopters ranging from –5 to +3 diopters if the built-in adjustment range is not enough. Therefore, the possible range of diopter adjustment extends from –6.5 to +4.

Adjusting the eyepiece to your visual acuity is very easy. First, take off the lens and look through the viewfinder at an evenly illuminated surface (such as the sky or a wall). If you want to use a lens for this exercise, use a telephoto, but do not focus it (it has to produce an out-of-focus image). Now adjust the diopter adjustment lever located to the right of the eyepiece until the focusing brackets and the center-weighted metering circle etched in the ground glass appear sharp and contrasty.

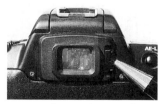

Next to the eyepiece is a lever you can use to customize the diopter to your eyesight.

Loading Film

Before loading a roll of film, always make sure that one is not already loaded. This can be done by looking at the LCD panel or at the film window on the camera back. If no roll is loaded, not only will the film window be void, but no film canister symbol will appear on the LCD panel, and an "E" will be displayed in the frame counter field.

To open the camera back, push the camera back lock release down. To close the back, just press the door shut.

If a roll is loaded, check the LCD panel to see whether it has been rewound or whether it is in the middle of the roll. If the film canister is flashing and there is an "E" in the frame counter field, the exposed film has been wound back into the canister and it is safe to open the camera back.

To open the camera back, slide the camera back lock release down in the direction of the arrow. Take the old film cassette out, and insert the new cassette into the film chamber with the film leader extending to the right. Pull the leader out until it reaches the red mark on the right, below the take-up spool. The edges of the film must be parallel to the metal film rails so that the film is running in the film channel, and the film must be as flat as possible. If you inadvertently pull too much film out, take the film canister out of the chamber and rewind the excess film by turning the spool in the center of the cassette. Then reinsert the cassette and try again.

Caution: *Load film in a dark location or at least in the shade of your body. Never load film in direct light because it can fog the film. Also, when the camera back is open, do not touch the shutter curtains as they are delicate and easily damaged.*

When the camera back is closed, the camera automatically advances the film to its first frame. This happens even if the camera's main switch is turned off. If the camera is on, the film

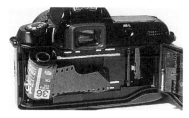

Load the film cassette into the film compartment by inserting it slightly at an angle. With the cassette in place, pull the film leader out to the right until it reaches the red index below the take-up spool.

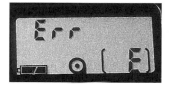

If film has been loaded improperly, the LCD panel will give you plenty of warning. The film canister will blink, an E will appear in the frame counter, and Err may appear at the top of the display.

cassette symbol and the number 1 (designating the frame number) appear on the LCD panel. If the film was loaded improperly, an "E" for Error will show in the frame counter field of the LCD panel, "Err" may appear at the top, and the film canister symbol will blink.

Film Speed

Film speed is the measure of a film's sensitivity to light. This value is indicated on all films as an ISO value (ISO stands for International Standards Organization). ISO values are numerically identical to the traditional ASA designations—a film of ISO 100 has an ASA value of 100. ISO values follow an arithmetic progression, in which a doubling of the value indicates a doubling in the film's sensitivity to light—an ISO 200 film is twice as sensitive to light as one of ISO 100 and half as sensitive as an ISO 400 film. The intervals on the N60/F60's ISO scale are ISO 25, 50, 100, 200, 400, 800, and continue up to ISO 5000.

Film speed is set automatically on the Nikon N60/F60. The camera can accept only DX-coded films with sensitivities between ISO 25 and ISO 5000. The N60QD can use only DX-coded films with film speeds of ISO 32 to 3200. There is no way

to set the film speed manually, therefore you cannot push-process or pull-process your film by setting a different film speed from that encoded on the cassette.

Film speed is set in 1/3-stop increments. You can check the automatically selected film speed by pressing the aperture and exposure compensation buttons simultaneously (for less than 2 seconds). The film speed is briefly displayed on the LCD panel in place of the shutter speed.

Film Advance

The Nikon N60/F60 advances the film automatically to the first frame when a roll of film is installed and to the next frame after each exposure is made. It also rewinds the film automatically when the end of the roll has been reached or the mid-roll rewind button has been pressed. The standard setting for all modes (except Sport mode) is single-frame film advance in which the shutter release is pushed once for each exposure. In Sport mode, the N60/F60 operates in continuous-frame advance. In this mode the camera fires approximately one frame per second for as long as the shutter release remains depressed. This makes sense if you are shooting sports or action photos in which you need to capture a series of shots of a moving subject or capture a particular movement. The Nikon N60/F60's motorized, program-determined film transport system increases its readiness for firing and ease of use.

Film Rewind

After the last frame has been shot, the Nikon N60/F60 automatically rewinds the exposed film into the cassette. When this is done, the cassette symbol on the LCD panel flashes, and the frame counter reads "E." Do not open the back before these two indicators appear. If you want to rewind a partially exposed roll of film prematurely, press the mid-roll rewind button on the bottom of the camera.

Reloading a Partially Exposed Roll of Film

Let's say you rewound a roll of 36-exposure film after the fourteenth exposure. Because the camera pulls the leader entirely into the cassette when it rewinds the film, you'll need a film leader retriever to pull it out so you can reload the film at a later

The mid-roll rewind button is on the camera's base. Pressing it rewinds the partially exposed roll back into the cassette.

date. A film leader retriever is an inexpensive little device that can be obtained from most camera stores. Once you have pulled the leader back out of the cassette, load the roll as you would a new one. Set the exposure mode dial to M, the shutter speed to 1/2000 second, the aperture to its smallest setting (largest f/number), and the focus mode selector to M (manual focus). Cover the eyepiece and put the lens cap on the lens. In a dark location, press the shutter release until the frame counter reads 15... or 16 to be on the safe side. You can now finish the roll shooting normally.

A Quick Guide to Shooting

If you would like to start shooting with your Nikon N60/F60 before you finish reading this book, follow these steps:

1. Load the camera with batteries and film.
2. Turn the main switch from OFF to ON.
3. Set the lens' smallest aperture (largest aperture number) and lock it by sliding the minimum aperture lock on the lens to the orange mark.

4. Set the exposure mode dial to the green camera symbol (General-Purpose Program Auto mode).
5. Aim the focusing brackets at the subject and touch the shutter release lightly to achieve focus.
6. Check the black dot (focus indicator) at the base of the viewfinder display to see that it is displayed but not blinking.
7. While continuing to hold the shutter release partway, recompose the image if necessary.
8. Press the shutter release down completely to take the picture.

Camera Handling and Shooting Techniques

Taking the first few photographs with a new camera can make anyone a little insecure. Factors that can affect the success of your shots are usually related to camera handling and shooting techniques. Reading this chapter before you start will considerably increase your success rate.

How to Hold the Camera

If a significant number of your photos come back blurred, despite the N60/F60's state-of-the-art autofocus technology, the fault is probably neither with the camera nor the lab, but rather with the photographer's camera handling and shooting techniques. Secure camera handling is required to produce sharp, clear photos!

Using proper hand-holding technique ensures steady shots in both horizontal and vertical formats.

A steady camera requires a steady stance, so establishing good contact with the ground is important. Place your feet approximately shoulder-width apart, or for low camera angles, rest one knee on the ground. Don't tense up—relax. Hold the camera with your right hand. Your thumb should fall between the AE-L button and the command dial, and your index finger should rest on the shutter release. The remaining three fingers should be grasping the hand grip. Now hold the camera's eyepiece up to your eye and press the camera against your nose and eyebrow. Your head will be slightly to one side of the optical axis. Place your elbows close to your sides. With your left hand, support the camera and lens from below. Your left thumb and index finger are free to operate the lens' zoom ring. This is the optimal way to hold the camera in the horizontal format.

For vertical shots, techniques vary. Some find it more comfortable to shoot with the right hand (camera grip) on top, and some find it more comfortable to shoot with the right hand (camera grip) below. Try it and see which one comes more naturally to you. That is the position that will give you the greatest stability.

Once you are holding the camera to your eye you'll find that all the controls you need to reach are easily accessed by your right thumb (command dial, AE-L button) or your right index finger (shutter release, exposure compensation button, aperture button). (The exposure mode, which determines the availability of all other camera functions, is generally selected before the camera is held in position.) These controls are equally accessible when shooting in horizontal or vertical formats.

Finally, though one would think that pressing the shutter release is quite simple, there is a technique that reduces the likelihood of camera shake: Relax, breathe calmly, exhale, hold your breath, and gently press the trigger.

Reducing the Risk of Camera Shake

Not only is breathing technique important to ensuring steady shots, but there is a rule of thumb for reducing the chance of camera shake. It states that the inverse of the focal length of the lens in use is the slowest shutter speed that can be safely hand-held without recording some camera movement. With a 50mm lens, this would be 1/60 second (1/50 second is not available with this camera), and with a 500mm telephoto, 1/500 second is the slowest speed to use hand-held. This rule of thumb cannot guarantee shake-free shots, but it can help you predict the potential for camera shake. If you demand perfect sharpness, you should select shutter speeds 1, or better yet, 2 stops faster. Therefore, a shutter speed of 1/1000 second or 1/2000 second makes sense with a 500mm lens.

Using the Self-Timer

The self-timer performs two important roles. It enables the photographer to appear in the photograph, and it can also be used to reduce the risk of camera shake. Use of the self-timer

allows the camera to stabilize after the photographer's finger has touched the shutter release. This type of shot should be done with the camera on a steady surface such as a tripod or table.

To activate the N60/F60's self-timer, press the self-timer button, which is located beside the exposure mode dial. The clock symbol appears on the LCD panel. Once the shutter release is depressed fully, the 10-second countdown commences. If autofocus is in use, the countdown begins only after the image is in focus. The countdown is indicated by the self-timer symbol blinking on the LCD panel and the AF-assist illuminator blinking on the front of the camera. For the first 8 seconds the illuminator blinks, and then for the last 2 seconds it glows steadily. If red-eye reduction is enabled, it is activated for the last 2 seconds.

If the photographer is not looking through the viewfinder when metering takes place (for example when the camera is mounted on a tripod), stray light can enter the viewfinder and confuse the metering system. The solution to this is to remove the eyecup and place the eyepiece cap over the eyepiece. This is not an issue with Manual exposure mode as exposure settings are determined manually and are unaffected by the camera's meter.

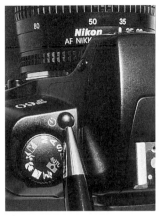

The self-timer function is readied by pressing the self-timer button.

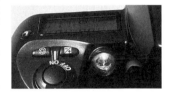

Once the self-timer is readied, the countdown doesn't commence until the shutter release has been pressed. The AF-assist illuminator will blink to signal the countdown's progress.

If autofocus is used, the main subject should be aligned with the AF sensor in the viewfinder, but focusing manually is also an option, allowing for more creative compositions.

If you change your mind after the countdown has commenced, the self-timer can be canceled in a number of ways. The easiest and least invasive way is to press the self-timer button again.

You can also cancel the self-timer by turning the main switch off (which turns the camera off) or performing the two-button reset (which resets any special settings back to their defaults). The self-timer function is automatically canceled if it has not been activated within 30 seconds after the self-timer button has been pressed.

The self-timer can be used in all exposure modes except Sport mode. It can be used with the built-in flash as well as with any system-compatible flash unit. All flash modes are available with the self-timer.

Long Time Exposures

Long time exposures are often required for shooting evening scenes, fireworks, a starry sky, or multiple exposures and can be made automatically or manually with the N60/F60. In Shutter-Priority (S) mode, the photographer can select a shutter speed as slow as 30 seconds while the camera selects the appropriate aperture. Alternatively, selecting a small aperture in Aperture-Priority (A) mode automatically leads to the selection of longer shutter speeds. In Manual exposure (M) mode, the photographer can select any aperture and shutter speed. Exposure times longer than 30 seconds are even possible in M mode as the Nikon N60/F60 offers a function that is very rare in today's SLR cameras: a T (Time) setting. (Most cameras have a Bulb setting instead, whose length of exposure is determined by how long the shutter release remains pressed.) Exposure times of any desired length are possible with this function, within the constraints of the batteries' life. A fresh set of lithium batteries can support an exposure lasting 15 hours.

When indoor shots are taken with a long exposure, a tripod is required.

The T setting can be selected and used only in Manual exposure mode. It is located after "30," at the end of the shutter speed sequence. Two lines (--) appear on the LCD panel. All other displays on the LCD panel and in the viewfinder disappear. The shutter opens when the shutter release is depressed. The right line on the LCD panel then starts blinking while the left

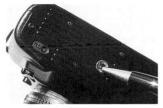

The Nikon N60/F60's tripod socket is on the camera's base, making it easy to attach.

one remains steady. To end the exposure, touch the shutter release lightly (pressing it all the way is unnecessary).

Note: If Shutter-Priority mode is selected and a long time exposure was previously made in Manual mode, the two lines (--) will appear on the LCD panel. The lines flash and the shutter release remains locked until a shutter speed is selected.

Quick Two-Button Reset

The N60/F60 has a two-button reset feature that returns the camera quickly to its default settings. This can be helpful if you inadvertently made a wrong selection or if you deliberately want to cancel settings quickly. The two-button reset function is not specifically marked on the camera, but it is easy to do nonetheless. To activate the two-button reset, simply hold the aperture button and exposure compensation button simultaneously for more than 2 seconds. In the first 2 seconds,

All camera functions can be quickly returned to their default settings by pressing the aperture button and the exposure compensation button simultaneously.

the automatically set, DX-coded film speed is displayed. After 2 seconds have passed, the following functions are reset to their original settings:

❑ Exposure compensation is set to 0.
❑ Flexible Program is set to 0.
❑ Flash synchronization is set to normal sync in all modes except Night Scene, which is set to slow sync flash.
❑ Self-timer is turned off.

Choosing the Right Film

Selecting a film is one of the most important decisions you have to make. The two most basic questions that must first be answered are: Slides or prints? Color or black and white? There are no universal answers to these questions. Each photographer has different reasons for selecting a particular film.

Consider what your photographs are going to be used for—album viewing, display, or projection. Your choice of film should also depend on the subject you are shooting. If you intend to take portraits, pick a film that produces good skin tones. Brilliant landscapes or detail-rich architecture are best served with slow films, such as ISO 50. Wildlife and sports photographers may prefer faster films depending on lighting conditions and the speed of their telephoto lenses (ISO 400 with a slide film, up to ISO 800 for negative films and paper prints, particularly with slow tele-zooms). Slide films of ISO 100 to 200 and negative films of ISO 200 to 400 have become standards for travel and vacation photography.

Specific advantages and disadvantages of the various films can be summarized as follows:

❑ It's easier to evaluate a slide than a negative.
❑ Slide films have a narrower exposure latitude than negative films. They therefore require a very precise exposure (deviations of 0.5 EV are apparent).
❑ Negative films have a wide exposure latitude. Exposure errors of –2 EV or +3 EV on a negative can still produce acceptable pictures. Color accuracy and sharpness can be affected by the quality of the work performed by the lab.

❑ Slow films of ISO 25 or 50 have extremely fine grain, producing great brilliance and color saturation. Unfortunately, they tend to have higher contrast and lower tolerance for exposure errors. Also, blur due to camera shake and/or subject movement is a greater danger with slow films than with faster films.

❑ Moderately sensitive films of ISO 100 to 200 are fine-grained and sharp with acceptable brilliance and color saturation. Contrast range and exposure latitude are midway between slow and high-speed films.

❑ High-speed films of ISO 400 to 3200 become grainier with increasing sensitivity but are not as contrasty. Brilliance and color saturation also decline noticeably. As a general rule, exposure latitude increases with the film's sensitivity.

Focusing

Many factors contribute to the success of an image. The aperture has a decisive influence on image quality in terms of sharpness and depth of field. Equally important is the shutter speed, which must be matched to the lens' focal length and the subject's speed. Exposure must be correct for the particular film in use. Finally, focusing must be accurate, which requires an appropriate focusing screen and a properly adjusted viewfinder, and with autofocus lenses, the focusing point must be carefully selected. In this chapter we'll discuss how to optimize focusing with your Nikon camera.

Lenses produce a sharp image only at their focal point. Focusing for a photograph requires that the focal point and the film plane converge. This is achieved by moving the elements within the lens. With the Nikon N60/F60 this can be done either manually or automatically. Both autofocus (AF) and manual (M) focus systems have advantages and disadvantages. Understanding these differences is helpful in selecting the best focusing method for the situation or subject matter.

The N60/F60 boasts a very fast and accurate autofocus system that is reliable even in complex photographic situations, as long as you know how to use it. However, because autofocus is not the best solution for every situation, you should learn to recognize those times when it is better to focus manually.

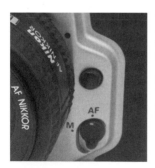

The focus mode selector is located on the front of the camera below the lens release button. To activate autofocus, set the switch to AF and mount an autofocus lens to the camera. Never attempt to focus manually with the switch set to AF. To focus manually, set the switch to M.

The Autofocus System

The N60/F60 contains Nikon's Advanced AM200 autofocus module with a centrally located line sensor. The AF system works best with Nikkor AF-D lenses, but of course, other Nikon-compatible AF lenses can also be used.

Auto-Servo, Single-Servo, and Continuous-Servo AF

The N60/F60's autofocus system automatically uses Auto-Servo autofocus in all autoexposure modes except Sport mode. Auto-Servo AF is a "smart" AF system, which decides between Single-Servo AF and Continuous-Servo AF depending on the situation. Auto-Servo AF's first choice is Single-Servo AF with focus priority. Single-Servo means that focus is locked on the subject when the shutter release is pressed partway. Focus priority means that firing can occur only once focus has been achieved. Single-Servo AF is ideal for photographing stationary objects because it gives you time to focus, compose, and shoot.

As soon as the AF sensor detects subject movement, the camera's computer automatically switches to Continuous-Servo AF with focus tracking. This shift can occur even if focus is already locked. Continuous-Servo AF tracks focus on a moving subject for as long as pressure is maintained on the shutter release. Focus is therefore constantly maintained on the moving subject. Focus priority is also used with Continuous-Servo AF.

The Nikon N60/F60 is programmed to use Continuous-Servo AF in Sport mode, because this program is designed for subjects that are usually in motion.

Focus tracking works best if the subject is moving towards or away from the camera at a constant speed. If the subject is moving across the field of view or is accelerating or decelerating, you're out of luck. The Nikon N60/F60's software does not accommodate that kind of movement.

Activating Autofocus

Before you can use the N60/F60's autofocus system, the focus mode selector on the front of the camera must be switched to AF. The autofocus area is indicated in the center of the viewfinder by two brackets. Point the brackets at the subject and press the shutter release partway to activate the autofocus system. Keep the

shutter release pressed lightly until focus is achieved (the in-focus indicator on the viewfinder display remains on). Recompose if necessary and press the shutter release all the way to take the picture.

AF System Limitations

If the in-focus indicator is flashing in the viewfinder display and the shutter release cannot be pressed all the way down, the autofocus system is telling you that it cannot focus on the subject. This could be for a variety of reasons, one of which is that the subject is beyond the range of the lens'—close-focusing distance, but there are more, and we will discuss them all.

The Nikon N60/F60's AF system reacts to reflections of light off the subject. It is therefore dependent on the brightness and contrast of the subject being photographed. So if an object is very dark, very bright, or has very little contrast, the AF system may

The N60/F60's autofocus system works best with subjects such as this that have good contrast.

not respond to it. Flat, monochromatic surfaces that lack a defined texture or pattern are other problematic subjects.

If objects are located between the subject and the camera, the AF system can also be fooled. However there is a solution: Focus on something that is the same distance away as the subject, lock focus on it by maintaining light pressure on the shutter release, recompose the image, and shoot.

Highly reflective surfaces and backlit subjects can also confuse the AF system. Manual focusing is the solution for this situation.

One final limitation of this AF system is that the AF line sensor cannot focus on strong, linear, horizontal structures (those that are parallel to its orientation). In such a situation, tilt the camera until the sensor is at a slight angle to the structure in question. Then lock the focus setting, compose, and shoot.

Focus Lock and Image Composition

The Nikon N60/F60's AF sensor is located in the center of the viewfinder and is surrounded by the center-weighted average metering cell. Optically, the arrangement looks like a target, which strongly influences image composition, producing the unconscious tendency to place the main subject in the middle of the frame. If the main subject is located in the center of the image and is covered by the centrally located AF sensor, all you need to do is look through the viewfinder and fire. However, good image composition sometimes demands that the subject not be located in the center of the frame, but rather a little to one side or lower in the frame, for example, when following the Rule of Thirds.

An off-center composition usually requires that you lock focus on the subject. To do this, point the AF metering cell at the subject, press the shutter release lightly, and when focus is achieved, the in-focus indicator on the left of the viewfinder display stops flashing. As long as you maintain pressure on the shutter release, you can recompose your image and be

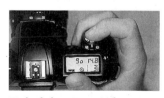

To lock focus, press the shutter release partway down and maintain steady, light pressure on it. When you are ready to make the exposure, press the shutter release all the way down.

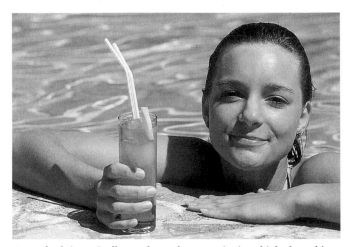

Focus lock is typically used to take portraits in which the subject is off-center. If focus had not been locked on the subject's face, the camera would have focused on the water.

assured that focus is maintained. (If you take your finger off the shutter release, focus will be lost.) To take the picture, press the shutter release all the way down. Focus can be locked in all modes except Sport, because Continuous-Servo autofocus is the default setting, and it tracks focus continually until the photo is taken.

Note: Holding the shutter release partway down locks only the focus setting, not the exposure. Exposure is optimized for the lighting conditions of the final image composition. If you want to lock a specific exposure setting, you need to press the AE-L button.

The AF-Assist Illuminator

Every autofocus system needs light to focus, and the N60/F60's Advanced AM200 autofocus module is very sensitive to light. Its effective range starts at EV –1 (at ISO 100 with an f/1.4 lens) and goes up to EV 19. It can do its job at dusk or in candlelight, and with the AF-assist illuminator it can even focus on a subject in complete darkness.

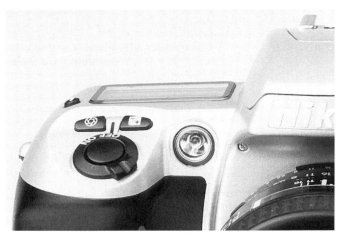

The AF-assist illuminator is located on the front of the camera between the prism and the hand grip.

The AF-assist illuminator is the small light on the front of the camera next to the shutter release. If you press the shutter release in darkness, the AF-assist illuminator automatically lights up and shuts itself off once focus has been achieved. At that point the focus indicator in the viewfinder stops blinking. The AF-assist illuminator can not be turned off manually; it comes on automatically if the camera's electronics determine it is necessary.

As its name implies, the AF-assist illuminator helps the autofocus system; it does not operate in manual focus. It can be utilized in every autoexposure mode except for Landscape and Sport mode. The AF-assist illuminator works best with lenses between 24mm and 200mm. Take care when using large lens hoods as they can interfere with the path of the AF-assist beam.

In promotional materials Nikon claims that this lamp has a range of 1.6 to 9.8 feet (0.5 to 3 meters). However, in our experience we found that its effective range indoors in complete darkness is as much as 32.8 feet (10 meters).

The AF-assist illuminator has two additional functions: red-eye reduction and visual countdown for the self-timer. See pages 158 and 39 respectively for more information on those camera functions.

Should you be using a Nikon-dedicated flash with AF-assist capability, its AF-assist function will be used. However when a non-dedicated flash or a Nikon-dedicated flash in Manual mode are mounted to the camera's hot shoe, the camera's AF-assist function will be used.

Manual Focus

Despite all its undisputed advantages, autofocus isn't the solution for everything. You will always run across subjects and lighting conditions for which manual focusing is more appropriate than autofocus. Or, you may own some lenses that are incompatible with the Nikon N60/F60's AF system—older non-AF lenses, AF-S and AF-I Nikkors, or AF-I teleconverters, for example. Other specialized Nikkors, such as mirror lenses or shift lenses, are designed specifically to be focused manually. Some accessories, such as bellows units, make autofocus impossible. Depending on the situation, you can usually check focus visually on the ground glass with nearly every lens, or use the electronic rangefinder's focus-assist feature (see below).

To focus manually, the focus mode selector beside the camera's lens mount must be set to M. *Do not attempt to focus manually when the selector switch is set to AF as this can damage the AF motor.* To focus, turn the lens' focusing ring until the subject appears sharp on the ground glass. This focusing method is very useful when creating compositions with stationary subjects. It allows you to concentrate fully on the subject and the composition without having to align the autofocus brackets with the subject and instead focus on any part of the ground glass. Also, manual focusing is indispensable with low-contrast, monochromatic surfaces and other situations that are difficult for the AF system to interpret. Finally, a clean and correctly adjusted eyepiece is crucial to precise manual focusing. See page 31 for information on diopter adjustment.

Focus Assist with the Electronic Rangefinder
The Nikon N60/F60 has an additional feature that makes manual focusing a little bit easier—an electronic rangefinder. This

rangefinder is merely an extension of the AF system—it confirms that what you have manually focused on is indeed sharp. It does not operate unless the focus mode selector is set to M. *And, it assesses only the focus of the object aligned with the camera's AF sensor.*

Focus manually and press the shutter release partway down. Once sharp focus has been achieved by turning the focusing ring, the focus indicator in the viewfinder will light up (as when focus is achieved in AF mode).

The main advantage of this focusing aid is its accuracy, in case your eyepiece is dirty or you don't trust your eyesight to discern precise focus. A slight disadvantage is that you must concentrate on the AF indicator and the focusing brackets, which takes your attention away from your subject and the composition.

What Is Depth of Field?

Depth of field is the area in an image that is perceived as being in sharp focus. Although laws of optics allow only one subject plane to be in truly sharp focus on the image plane, the phenomenon of depth of field creates an illusion of sharpness in an area that extends in front of and behind that plane. The extent of that area's size is dependent on a number of factors, including (among others) the lens' magnification ratio and the set aperture. As a rule, the greater the focal length of a lens, the shallower the depth of field. The wider the lens' angle of coverage, the greater the depth of field at any given aperture. Depth of field is determined by the combination of the following factors:

Shallow depth of field:
❏ Large aperture (small f/number)
❏ Long focal length
❏ Short camera-to-subject distance
❏ Large magnification ratio
❏ Small diameter of the circle of confusion

Because depth of field extends farther backward than forward, focus manually on an object in the foreground that you want to have in focus. For most average shots, depth of field generally extends approximately 1/3 ahead of and 2/3 behind the plane of focus.

Large depth of field:
- ❏ Small aperture (large f/number)
- ❏ Short focal length
- ❏ Large camera-to-subject distance
- ❏ Small magnification ratio
- ❏ Large diameter of the circle of confusion

Utilize the Hyperfocal Distance to Optimize Depth of Field

In most general shooting situations, a lens' depth of field extends approximately 2/3 behind the plane of focus and 1/3 in front of the plane of focus. The hyperfocal distance is the closest point at which one can focus so that the depth of field includes infinity. A lens' hyperfocal distance is important for achieving optimum depth of field when taking snapshots or for controlling an image's composition when depth of field is a consideration.

The hyperfocal distance changes depending on the aperture in use. As with depth of field, the smaller the aperture, the shorter the hyperfocal distance; and the larger the aperture, the longer the hyperfocal distance. To determine hyperfocal distance at a given aperture, align the infinity symbol (∞) on the lens' focusing range scale with the f/number that corresponds to the set aperture on the depth-of-field scale. This will give you the most extensive depth of field at that aperture.

When the lens is set to its hyperfocal distance, the closest distance that will appear to be in focus is exactly half the hyperfocal distance. Therefore, if you set your lens at a hyperfocal distance of 10 feet, the closest object that will appear to be in focus will be 5 feet away.

Exposure Metering

The Nikon N60/F60 offers two different exposure metering modes: 3D matrix metering and center-weighted average metering. The camera uses 6-segment matrix metering when the lens that is mounted is unable to support 3D matrix metering. This chapter will explain basic and advanced metering concepts as well as how and when to use each specific metering method.

Each exposure mode in the N60/F60 is programmed to use the metering system that will produce correct exposure for the subjects for which the mode was designed. Difficult subjects and lighting conditions that have backlighting or areas of high contrast are a challenge to even the computer-controlled 3D matrix metering system. To evaluate and control such situations, a basic understanding of exposure metering is essential. This knowledge will help you make good exposure decisions so that you can capture unusual lighting realistically or use lighting creatively.

Nikon's 3D matrix metering can accurately assess a complex scene such as this with many areas of lights and darks.

Exposure Metering Basics

The Nikon N60/F60's 3D matrix exposure metering system is very advanced and allows you to handle a wide variety of subject and lighting situations automatically, and center-weighted average metering with autoexposure lock is very useful if you want to control the exposure precisely. However you need to know when to use each method. So first we'll explain how an exposure meter works.

All exposure metering systems measure the amount of light on the metering area. It doesn't matter if the meter is an external hand-held unit or an in-camera TTL (through-the-lens) version. This is true regardless of whether the light being measured is incident or reflected and regardless of the metering method (multi-zone, center-weighted average, or spot). TTL metering measures the light reflected from the scene through the lens and onto the metering cells. But the TTL system cannot tell if the same amount of light is bouncing off a dark subject under strong illumination or a light subject under weak illumination. This means that both dark and light surfaces turn gray, medium gray to be exact, if the metered value is used without correction.

The reason for this is that all meters are calibrated to assume that the scene's brightness levels average to a medium gray. Medium gray corresponds to a subject that reflects 18% of the light hitting it. All exposure meters will produce a reading that makes the metered area medium gray in the final image. This bit of information is very important to basic exposure determination. It also explains why bright subjects are underexposed and dark subjects are overexposed if one shoots using the TTL meter's exposure recommendation without compensation.

In conventional photography, a subject is comprised of surfaces and areas of different tones and brightness values. The Nikon N60/F60's 3D matrix metering system weighs the meter readings from the various segments, taking into account the focused distance, and thus exposes most subjects correctly. If, however, light or dark areas dominate the frame, even 3D matrix metering can generate incorrect exposures. Those who have familiarized themselves with the basics of exposure metering could set exposure compensation or sub-stitute meter on an appropriate area in a case such as this. Schools teach students to

A predominantly white subject photographed without correcting the exposure will most likely be rendered gray (left). Setting an exposure compensation factor of +2 EV corrects the tonality.

meter an 18% gray card under the same illumination as the subject. KODAK Gray Cards come in a set with two sizes, 8 x 10 inches [20.3 x 25.4 cm] and 4 x 5 inches [10.2 x 12.7 cm]; the latter fits easily into a camera bag. When this is not possible, use center-weighted average metering and substitute meter on grass, which reflects about half as much light as a standard 18% gray card. Then set exposure compensation of –1 EV and lock the exposure. No matter how sophisticated the metering system is, even simple shots can defeat a camera's automatic exposure metering system.

3D Matrix Metering

The N60/F60's 3D matrix metering system utilizes Nikon's advanced metering technology. It is compatible with all D-type lenses, AF-S, and AF-I Nikkors as well as AF-I teleconverters. The lens' aperture ring must be set on the smallest aperture (largest f/number) for this metering system to work, otherwise the shutter release will lock.

With the above-mentioned lenses, 3D matrix metering is the standard metering system for all exposure modes except Manual (M), which uses center-weighted average metering. This matrix system divides the image area into six segments, each of which is metered separately. Data concerning the distribution of illumination and contrast over the entire image area are analyzed by the camera's computer.

The D-type Nikkor lenses literally add a third dimension to the equation. These lenses feed the camera data concerning the

subject's distance. The nearly symmetrical distribution of the metering fields, the camera's "fuzzy logic" analysis, and the third dimension offered by the lens' distance information result in correct exposures in both horizontal and vertical formats. The 3D matrix metering system evaluates the position of the main subject in its exposure calculations, even if the subject is off-center, as long as the focus was locked on the subject before the image was recomposed.

The camera's matrix metering system divides the image area into six separate metering segments and meters each individually.

3D matrix metering is, without question, a highly technical, extremely advanced exposure metering system. It easily handles conventional subject and lighting conditions and even reacts quickly and accurately to moderately high-contrast subjects and more difficult lighting conditions. However, high and very high contrast ratios or strong backlighting can confuse even this sophisticated exposure system. In extreme backlighting situations, the electronics attempt to adjust the exposure, however the camera does not tell the photographer the extent of the exposure adjustment. Therefore the photographer cannot determine to what extent the camera has compensated the subject's exposure for the backlighting, making further exposure compensation by the photographer difficult.

Exposure values cannot be locked with 3D matrix metering. Pressing the AE-L button causes center-weighted average metering to kick in, but only as long as the button remains pressed.

6-Segment Matrix Metering

The N60/F60 automatically defaults to conventional 6-segment matrix metering when non-D AF or AI-P Nikkors are mounted. This metering system assesses the six metering fields just as it would with 3D matrix metering, however since distance information is not transmitted through these lenses, it is not part of the evaluation.

Center-Weighted Average Metering

Center-weighted average metering is automatically used in Manual exposure mode. It can also be activated in all other modes by pressing and holding the AE-L button. (This also serves to lock the exposure reading in memory.) As with matrix metering, the entire viewfinder area is measured, but the central 12mm area is given 75% of the weight in the metering calculation. The 12mm circle etched on the ground glass corresponds almost exactly to that area. The surrounding image area contributes 25% to the exposure calculation. The 75%:25% ratio between the central metering area and the surrounding image area remains constant regardless of the lens used.

The Nikon N60/F60's center-weighted average metering system, when used in conjunction with wide-angle and normal lenses, is very well suited to subjects within the normal range of contrast, those that have low color contrast, and those whose light and dark areas are evenly distributed. Center-weighted average metering is not as tolerant of complex lighting as 3D matrix metering, but with a little experience, you can judge its effect more accurately. Learning to work with this metering system is important if you want to deviate from the metered value or set exposure compensation.

Center-weighted average metering can be used with all AF-D, AF-S, AF-I, non-D AF, and AI-P Nikkors. When AF Nikkors are used, the aperture ring must be set to the smallest aperture (largest f/number) for the system to work. The aperture locking switch on the lens must be set to the orange index point. If this is not done, the shutter release will lock, preventing exposure.

As mentioned, the strong weighting of the central metering area allows you to selectively meter important sections of the image. However, keep in mind that the meter's angle of view matches the lens' angle of view. This means that the metering angle gets progressively smaller with an increase in the focal

With center-weighted average metering, the central 12mm area of the image frame receives 75% of the weight in the exposure calculation, and the balance of the frame receives only 25%.

A scene such as this is ideal for center-weighted average metering. The powerful cliffs of El Capitan in Yosemite National Park fill the center of the frame and are exactly the right shade of gray (18%) for metering.

length of the lens. Therefore, the longer the lens, the more targeted the metering.

Autoexposure Lock

To use the N60/F60's autoexposure lock (AE-L) feature, aim the central, 12mm metering circle at the area to be metered. Lock the meter reading by pressing and holding the AE-L button. (The exposure setting will remain locked for as long as the AE-L button is held down.) To autofocus, press the shutter release lightly. Then reframe the composition as desired and press the shutter release fully to take the exposure.

Since the metered value is locked as soon as the AE-L button is depressed, it is very important to aim the circle accurately before touching the button. Locking exposure using this button is not required in Manual exposure mode as exposure is set manually and will not change.

Advanced Metering Techniques

Exposure Compensation

The N60/F60's exposure compensation feature offers you the option of adjusting the camera's automatically determined exposure setting while maintaining the convenience of the automatic functions. Since using exposure compensation takes some experience, Nikon designed the N60/F60 so that it can be used only in the more advanced autoexposure modes: Auto-Multi Program, Shutter-Priority, and Aperture-Priority modes—not in General-Purpose or any of the Vari-Program modes. Exposure compensation can also be used in Manual exposure mode, but by its very nature, Manual mode gives you complete control over exposure, so exposure compensation is superfluous.

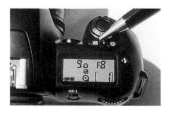

The exposure compensation (+/–) button is located on the top of the camera, between the shutter release and the LCD panel.

The Nikon N60/F60 allows exposure corrections within a range of +/–3 EV to be set in 1/2-stop (0.5 EV) increments. All you have to do is select the desired correction using the command dial while pressing the exposure compensation (+/–) button on the top of the camera. The analog scale in the viewfinder displays exact corrections within +/–0.5 EV. Larger corrections are indicated more generally by an arrow under the + or – symbol, depending on the direction of the correction.

Note: The analog scale in the viewfinder represents different values in exposure compensation than in Manual exposure (M) mode. In Manual mode the 0 can represent an exposure variance of +0.5 EV, 0 (perfect exposure), or –0.5 EV, while in exposure compensation the 0 actually means 0. In M mode the positions to the left and right of the 0 indicate deviations from +0.5 EV to +1.5 EV (left) and –0.5 EV to –1.5 EV (right). In exposure compensation they represent precise values of +0.5 EV and –0.5 EV. This slight incongruity does not have serious consequences as long as one is aware of it.

When exposure compensation is active, the +/– exposure compensation symbol appears both in the viewfinder and on the LCD panel. The exact amount of the correction can be seen at any time on the LCD panel by pressing the +/– button on the top of the camera. The selected correction remains active even if the camera is turned off; it must be canceled manually. There are two ways to do this: Select the value "0.0" while pressing the +/– button, or hold the +/– button and the aperture button simultaneously for more than 2 seconds (see "Quick Two-Button Reset" on page 41).

Exposure compensation can be used with both center-weighted average metering (with autoexposure lock) and 3D matrix metering. You can determine the amount of exposure correction more accurately with center-weighted average metering than with 3D matrix. This is because with center-weighted metering you can assess fairly accurately how the meter reading was derived and therefore select an appropriate correction. Correcting an exposure that has been set using 3D matrix metering is more problematic as you do not know to what

extent the camera has already compensated for the scene's lighting conditions in its exposure recommendation.

Even the most advanced exposure metering system has some limitations. Exposure compensation is useful for accurately exposing a high-contrast subject in strong backlighting and also for capturing certain moods. For a bright sunny beach, bright winter landscapes, and in strongly backlit situations an exposure adjustment of +0.5 to +3 EV might be required, depending on the lighting conditions and the composition of elements within the scene. Dark subjects, on the other hand, may require a minus correction. Care must be taken when shooting at dusk and at night. Theoretically, you should enter a minus correction as the subject is very dark. But if a shutter speed slower than 1 second is suggested by the camera's meter, reciprocity effects can come into play (see page 103) and may require a correction of +2 or +3 EV.

Exposure compensation can greatly influence the mood and atmosphere of an image.

High-key shots: High-key shots are composed mainly of light colors or values. They can exude either an energetic or an ethereal mood. Bright main subjects (in portraiture, still lifes, or nudes) in front of light backgrounds with practically shadowless lighting are standard situations in high-key photography. Controlled overexposure using a correction of +1 or +2 EV can intensify the look.

Low-key shots: Low-key shots are the opposite of high-key. They consist of predominantly dark tones with hardly any detail. Low-key shots have a dramatic "film noir" mood. Portraits, still lifes, and nudes in front of dark backgrounds with minimal lighting are ideal low-key shots. A controlled underexposure of –1 or –2 EV can increase the effect, depending on the subject. Catchlights or small, bright areas in the picture can also heighten the drama.

Exposure Bracketing
Exposure bracketing is the process of making a series of exposures at settings that surround the original metered value. In addition to the metered exposure, a number of over- and/or underexposed shots are taken. The Nikon N60/F60 does not have an automatic exposure bracketing function, however bracketing can be performed easily using exposure compensation. With this

This series demonstrates the different effects that can be produced by exposure bracketing.

method, the number of shots and the exposure variance between them can be selected as needed.

With negative film, we recommend that you take three shots: one at the meter's recommended exposure, one exposure that is 1-stop overexposed, and one that is 1-stop underexposed. With slide films, the exposure series could consist of 3 or 5 shots with a differential of 1/2-stop: –0.5 EV/0/+0.5 EV or –1 EV/–0.5 EV/0/ +0.5 EV/+1 EV. A bracketed sequence does not always have to include an uncompensated exposure. With strong backlighting, for example, a series of +1, +2, and +3 EV is an option.

To bracket exposures with a constant aperture, use Aperture-Priority (A) or Manual (M) mode. To bracket with a constant shutter speed, use Shutter-Priority (S) or Manual (M) mode.

Bracketing is often the only way a photographer can obtain a shot that is exposed the way he or she has in mind—whether the intention is a realistic rendering of a scene or the one with the most effective mood.

Bracketing is extremely useful for shooting slide films as they have a narrower exposure latitude than negative films and therefore have to be exposed more precisely. A few rules of thumb for selecting from a series of bracketed exposures are: A slide intended for scanning should be about 1/2-stop lighter than a slide intended for projection, and a slide projected using a 150-watt lamp should be a shade lighter than one projected using a 250-watt lamp.

Bracketing obviously increases film consumption. Normally, however, film is the least expensive step in the process. High expectations make bracketing indispensable with color negative films under difficult lighting conditions, even though these films have a large exposure range, and incorrect exposures can often be "saved" in the printing process. However, the overall quality of prints produced from improperly exposed negatives can never match those made from well-exposed negatives.

There are many approaches that can be taken with architectural ⇨ photography. Here, a telephoto zoom was set at 250mm to compress the space. The large distance reduced the potential for converging lines and created the perspective. The image is fairly accurate in rendering what the eye perceives when viewing a scene such as this. But it is not as dynamic as the wide-angle shot on page 69.

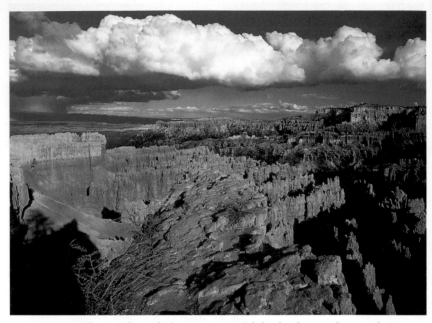

A 20mm lens and a polarizer are essential for landscape shots such as this. The image has enormous depth, emphasized by the rock outcropping in the foreground. The polarizer made the sky richer and drew out the detail in the clouds.

Page 67 top:
In Greek, photography literally means "writing with light." In this shot ⮕ you can see exactly how important light is to photography. The sun is low in the sky and has a low color temperature, which together lend an almost mystic aura to the rock spires of Bryce Canyon.

Page 67 bottom:
Landscape photography does not have to be limited to wide-angle lenses. This detail shot was taken from a long distance with a 300mm lens. Since I did not have a tripod to steady my lens, I sat down and balanced the telephoto on my knee and selected a shutter speed of 1/500 second.

This shot was taken with a 20mm lens at f/11, creating a relatively wide depth of field. The wide-angle lens and the angle that the photographer chose to shoot from emphasized the converging lines and gave the face on the kiosk a dynamic appearance. This image's strength lies in the contrast between the oversized face in the center and the receding skyscrapers surrounding it.

◁ Using the N60/F60's Flexible Program feature, I turned the command dial to shift the Program mode's recommended exposure to a larger aperture and a shorter exposure time. The faster shutter speed reduced the risk of camera shake (at 135mm), and the larger aperture separated the subject from the background.

The Vari-Program for portraits is not just for classic portraiture. Its bias towards selecting large apertures also results in fast shutter speeds which, in turn, reduces the risk of camera shake in telephoto shots (here, a 200mm lens was used).

Polarizers don't have to be relegated only to landscapes. A polarizer saturates colors, which in this case works to emphasize the model against the deep blue sky.

71

Controlling Contrast

Even if the exposure is "correct," extreme subject contrast can result in an unappealing image. It is more difficult to control contrast in shots taken outdoors than in the studio, as you can't fully control the sun's illumination. However, there are ways to control outdoor lighting. In portraits or still lifes, the subject can be positioned so that light and shadow combine to provide the desired amount of contrast. Brightening shadows using collapsible reflectors, Styrofoam, or even bed sheets can help. Another technique, the one preferred by professional photographers, is to take the shot when the position of the sun produces the desired contrast ratio. This requires the photographer to have a great deal of patience, and may even require returning to the scene later in the day.

One can also control contrast in landscape photography by using graduated neutral-density filters. Graduated neutral-density filters allow the photographer to reduce the contrast between a bright sky and the foreground. High-quality graduated neutral-density filters do not affect subject colors at all. Manufacturers such as Tiffen and Cokin make many different kinds of graduated filters. Those made by Cokin can be positioned and turned in any desired position.

◁ **The N60/F60 is so versatile, it can take professional-looking studio portraits, detailed close-ups, as well as travel snapshots.**

Compensating this exposure by –1 EV helped render these cigars a more natural, dark tone than they would have been if the meter's recommended exposure had been used.

Another method of controlling subject contrast is to use the N60/F60's matrix-balanced fill flash. See page 157 for more information.

The range of contrast within a scene can be easily determined using the Nikon N60/F60's center-weighted average meter. This is done by taking a meter reading of the brightest and the darkest areas in which you want to show detail. Meter using a long focal length to narrow the angle of view (allowing you to meter more precisely on a certain area). Or, an even better method is to use a spot meter or a hand-held meter with a spot attachment. First meter the darkest area in the image in which you want to show detail, and then meter the brightest area in which you want to show detail. When selecting these areas, take care not to choose the brightest highlight or deepest shadow that has no detail. Both meter readings should be taken with the same aperture and shutter speed so that the difference in exposure can be easily determined.

HI and LO Warnings
In every mode except Manual, if exposure is too bright or too dark for the set exposure, the LCD panel and viewfinder display a

The definition of the clouds in this image was enhanced by use of a graduated neutral-density filter.

warning. If the subject is too bright for the setting, "HI" is displayed. A neutral-density filter can help cut down on the brightness, bringing the exposure back into the camera and film's range. If a subject is too dark for the exposure setting, "LO" is displayed. Use of flash is recommended. These warnings are displayed in the shutter speed field in all modes except Shutter-Priority, in which case they are displayed in the aperture field.

Exposure Modes and Creative Effects

The Nikon N60/F60 offers ten exposure modes—a range that is wide enough to accommodate any photographic need. With the N60/F60's sophisticated exposure system, good exposures of any type of subject are possible.

Each mode is customized with functions (such as 3D matrix metering or center-weighted average metering, Auto-Servo or Continuous-Servo autofocus, single-frame or continuous-frame advance) that will give the best results for a given subject or purpose. This means that instead of setting each function individually on the camera, you can simply select one of the camera's exposure modes or Vari-Programs, and the settings will be made for you. Each exposure mode is designated on the exposure mode dial by a letter or symbol so that even when the camera is turned off, you can see which mode is set.

Deciding Which Mode to Choose

This brief overview will help you take the best advantage of the N60/F60's versatile exposure modes. A more extensive discussion of each mode follows later in this chapter.

"Green" General-Purpose (AUTO) Program mode: Ideal for beginners, newcomers to SLR photography, and people who want to "point and shoot" on fun occasions. It is fully automatic; no manual adjustments are possible or necessary, and it still makes excellent exposures. This mode is suited to taking snapshots and well-exposed photos of most any average subject. (It is not intended for creative effects.)

Auto-Multi Program (P) mode: Fully automatic mode that differs from General-Purpose mode in that it allows some exposure control by the photographer, such as shifting the aperture and shutter speed to set an equivalent exposure (Flexible Program), exposure compensation, and slow sync flash.

Flexible Program (P*): A variation on Auto-Multi Program mode. Allows the photographer to select alternate but equivalent aperture-shutter speed combinations for more creative control over the Program exposure settings.

Shutter-Priority (S) mode: Allows the photographer to select the shutter speed to control how motion is depicted in the image. The camera selects the corresponding aperture for proper exposure. Recommended for demanding sports and wildlife photography with telephoto lenses.

Aperture-Priority (A) mode: Allows the photographer to select the aperture required to produce the desired depth of field in the image while the camera selects the corresponding shutter speed. Good for portrait and scenic photography where control of depth of field is essential.

Manual (M) mode: Offers unlimited selection of both aperture and shutter speed by the photographer without any camera-induced overrides. The exposure that the photographer sets is what the camera will use regardless of the metered exposure. (The viewfinder displays the camera's metered exposure so that the photographer can judge the deviation between the manual and the metered exposure settings.) This is ideal for shooting difficult lighting situations or for creative expressions.

Portrait mode: Produces professional-looking portraits with a sharply focused subject against a blurred background. This mode favors a wide aperture.

Landscape mode: Optimal for broad landscapes with extensive depth of field. This mode favors a narrow aperture.

Close-up mode: Ideal for shooting close-ups and small still lifes. This mode sets an aperture of f/5.6 if possible.

Sport mode: Ideally suited to action, sports, and wildlife photography with longer focal length lenses. This mode sets a fast shutter speed, which is likely to stop action and reduce the risk of camera shake.

Night Scene mode: Designed to balance subject (flash) illumination and background (ambient) illumination in a portrait taken at night or in a darkly lit room. It is best suited for night shots of people or groups in front of an illuminated background (fountain, storefront, house, etc.).

"Green" General-Purpose (AUTO) Program Mode

General-Purpose Program mode is designed to take properly exposed photos completely automatically. It is especially well suited to taking quick snapshots when you don't have time to waste figuring out what camera settings you should use. *Everything* is set automatically in this mode—all manual control options are locked! General-Purpose mode is designed so that you can be assured of obtaining sharp and properly exposed photographs without being burdened by camera controls and technology. That way, you can concentrate fully on what is happening around you.

Turn the exposure mode dial to the green "AUTO" camera symbol to set General-Purpose Program mode.

Hint: Natural, spontaneous images are often more appealing than posed ones. Snapshots can capture an amusing scene or a moving incident. One can anticipate such situations by observing a scene and waiting for the right moment. Good snapshots require quick reflexes, constant readiness, and a lot of patience.

The N60/F60's General-Purpose mode is easy to find on the exposure mode dial. It is represented by a green camera symbol, the word "AUTO," and a raised dot. To select this mode, turn the dial so that the green symbol aligns with the index on the camera.

Snapshots are easy to take in General-Purpose Program mode. All you ⇨ need to do is look through the viewfinder and press the shutter release. Focus and exposure are set automatically.

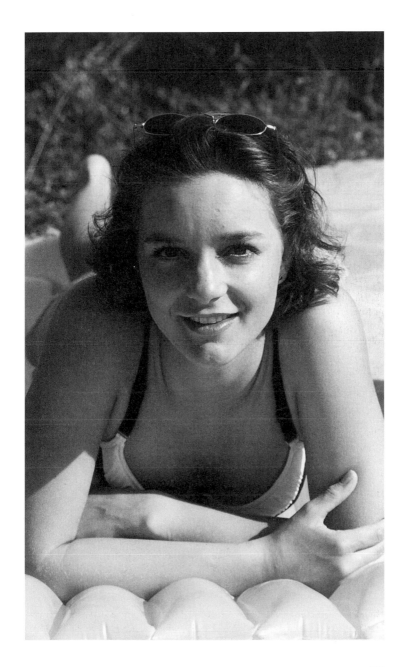

It is very important that the lens' smallest aperture be set so that the camera's electronics perform properly. If this is not done, the shutter will lock, and the error message "FEE" will appear on the LCD panel as well as in the viewfinder. To lock the lens at its minimum aperture, turn the aperture ring to its smallest aperture (the largest f/number, engraved in orange) and then slide the minimum aperture lock switch so that its white dot aligns with the orange index on the lens.

General-Purpose mode uses 3D matrix metering with D-type, AF-S, and AF-I lenses (6-segment matrix metering with other AF lenses). It also utilizes single-frame advance, and Auto-Servo autofocus, which automatically switches from Single-Servo to Continuous-Servo autofocus if the camera detects subject movement.

The built-in flash will fire a full flash or fill flash whenever the program determines it is necessary. And true to the mode's fully automatic design, it will not allow you to select a creative option such as slow sync flash. Other manual exposure manipulations such as Flexible Program (Program Shift) and exposure compensation are also not possible. However, focus lock, autoexposure lock, manual focusing, and the self-timer are available. The AF-assist illuminator is automatically enabled if the camera determines it is required. Exposure information such as shutter speed and aperture as well as the in-focus indicator and flash ready light appear in the viewfinder display.

General-Purpose mode is designed for taking standard subjects with moderate contrast. If you intend to try a creative effect such as freezing the motion of a moving subject or making a portrait with a blurred background, Sport or Portrait mode, respectively, are better suited to those tasks.

Hint: When taking flash photos in General-Purpose mode, be sure to position the subject within the flash unit's range. Also, if the main subject is located off-center in the composition, aim the AF sensor directly at the subject and lock focus by pressing and holding the shutter release partway down. Then, just recompose and press the shutter release all the way down to take the photo.

Auto-Multi Program (P) Mode

Auto-Multi Program (P) mode is a very flexible, universal exposure mode. The N60/F60 automatically selects both the shutter speed and aperture by taking into consideration the focal length of the lens as well as subject, contrast, and distance information. This mode is activated by turning the exposure mode dial until the letter P aligns with the white index on the camera. Program mode is only operational if the lens' smallest aperture (the largest f/number, engraved in orange) is set or locked. To lock it, slide the aperture lock switch so that its white dot aligns with the orange index. (If the error message "FEE" appears on the LCD panel and in the viewfinder, the smallest aperture is probably not set .)

Both beginning and advanced photographers can benefit from the speed of the automatic exposure control that this mode delivers in countless photographic situations. It is ideal for snapshots and other spontaneous pictures, and, unlike General-Purpose mode, it gives you the ability to control some settings manually— exposure compensation, slow sync flash, and exposure settings through the Flexible Program (Program Shift) feature.

Turn the exposure mode dial to P to use Auto-Multi Program mode.

In this mode, the Nikon N60/F60 uses Auto-Servo autofocus, which defaults to Single-Servo autofocus until subject movement is detected, at which time it shifts into Continuous-Servo autofocus. Other default settings in this mode include single-frame advance and 3D matrix metering (with D-type, AF-S, and AF-I lenses; 6-segment matrix metering is used with all other AF lenses). Auto-Multi Program mode also allows you to use autoexposure lock (AE-L) with center-weighted average metering when precise exposure measurement is required.

Unlike General-Purpose mode, exposure compensation is possible in Auto-Multi Program mode. Pressing the exposure compensation button and turning the command dial sets the desired amount of compensation within a range of +/–3 EV in

1/2-stop increments. The selected exposure adjustment is displayed by pressing the exposure compensation button. The exposure compensation setting is maintained even if the camera is turned off. A setting is canceled the same way it is set: Press the exposure compensation button and turn the command dial until the LCD panel reads "0.0" in the lower right-hand corner. If the exposure mode dial is turned to General-Purpose mode or a Vari-Program mode while exposure compensation is set, the system ignores the exposure compensation setting until P, S, A, or M mode is selected, at which time exposure compensation is reactivated.

You can also select slow sync flash in Auto-Multi Program mode. To set slow sync flash, press the flash sync mode button to the right of the LCD panel while turning the command dial until SLOW and a lightning bolt appear on the left of the LCD panel. The camera will automatically set a shutter speed slower than 1/125 second to record more ambient light in the background exposure.

All other camera functions are available for you to select manually in Auto-Multi Program mode, including self-timer and red-eye reduction.

Flexible Program (Program Shift)

Flexible Program (or Program Shift) is available in Auto-Multi Program mode, but not in General-Purpose mode. This function allows you to change the camera's automatically selected aperture-shutter speed combination at any time while maintaining an equivalent exposure value. You thus have the ability to combine your creative photographic intentions with the speed and accuracy of Auto-Multi Program mode. This could mean setting a smaller aperture for greater depth of field, a larger aperture for narrower depth of field, a faster shutter speed to freeze motion, or a slower shutter speed to blur motion.

To shift exposure, turn the command dial until the desired aperture-shutter speed combination appears in the LCD panel. A P* in a black box on the top left corner of the LCD panel indicates a shift has been entered. Exposure settings can be shifted in 1/2-stop increments.

The shift function is canceled after an exposure has been made; the original Program setting is then reactivated. If,

If the exposure settings in Program mode are not appropriate for creating the depth of field you need, turn the command dial to change the aperture. The shutter speed will change accordingly to maintain equivalent exposure.

however, you do not make an exposure after shifting, the shifted exposure setting is retained. To cancel it without taking a photograph, you have several options: Set the original shutter speed-aperture combination (the P* disappears), turn the exposure mode dial to another position, turn the main switch to OFF, or activate two button reset (press the exposure compensation and aperture buttons simultaneously for longer than 2 seconds).

Note: Flexible Program does not work if the built-in flash is flipped up or if an accessory flash is mounted and turned on.

Shutter-Priority (S) Mode

Shutter-Priority (S) mode allows you to determine how motion will be captured on film (sharp or blurred) depending on the shutter speed you select. The corresponding aperture is selected automatically by the camera to create proper exposure. Motion can be frozen by setting a fast shutter speed or blurred by setting a slow shutter speed. Shutter-Priority mode can also be used to reduce the possibility of camera shake with telephoto shots if a shutter speed faster than the reciprocal of the focal length is selected.

Hint: Pictures can be made of a television screen using Shutter-Priority mode. These turn out best if the shutter speed is set at 1/15 second and the camera is mounted on a tripod.

Shutter-Priority mode is represented by an S on the exposure mode dial. To select this mode, turn the dial until the S aligns with the index on the camera. When S mode is activated, the shutter speed last selected in S or in M mode appears. Select the desired shutter speed by turning the command dial. The Nikon N60/F60 offers shutter speeds between 1/2000 second and 30 seconds in 1/2-stop increments. The photographer-selected shutter speed and the camera-selected aperture are displayed on the LCD panel and in the viewfinder.

To use Shutter-Priority mode, set the exposure mode dial to S.

Shutter-Priority mode cannot operate unless the lens is set at its smallest aperture (the largest f/number, engraved in orange). However, the aperture does not have to be locked, though locking the lens at its smallest aperture protects against inadvertent changes and resultant error messages. If the lens is not at least set at its minimum aperture, the shutter release locks and the FEE error message appears on the LCD panel and in the viewfinder.

Unlike with Auto-Multi Program mode, in S mode you have to make sure that the available aperture range can accommodate the selected shutter speed to produce a correct exposure. If LO appears on the LCD panel and in the viewfinder, the lens' largest aperture is not sufficient to provide an adequate exposure. The Nikon N60/F60 will allow you to take the picture, but the photo will be underexposed. In order to prevent this, select a slower shutter speed until an aperture appears on the LCD panel instead of LO. Bear in mind that camera shake becomes a concern with longer shutter speeds. Depending on the focal length of the lens you are using, a tripod or other camera support may be helpful. You may wish to use flash if the subject is within its range. Mount an accessory flash unit and turn it on, or pop up the built-in flash.

Setting a fast shutter speed in Shutter-Priority mode is required to capture sharp photos of moving subjects.

The exposure will normally occur at f/5.6 and the manually selected shutter speed, as long as it is slower than the camera's flash sync speed of 1/125 second. If a shutter speed faster than 1/125 second is selected, the camera overrides the setting and sets 1/125 second automatically.

If HI appears on the LCD panel and in the viewfinder, the selected shutter speed is too slow for the lens' minimum aperture. The camera will allow the exposure to be taken, but the photo will be overexposed. Selecting a faster shutter speed will generally solve the problem. If the fastest shutter speed of 1/2000 second is still too slow (which is rather unlikely), a neutral-density filter will help.

In Shutter-Priority mode, the Nikon N60/F60 uses Auto-Servo autofocus, single-frame advance, 3D matrix metering with D-type, AF-S, and AF-I lenses, and 6-segment matrix metering with all other AF lenses. Exposure compensation and autoexposure lock with center-weighted average metering are also possible. However, red-eye reduction and slow sync flash cannot be used in this mode.

Aperture-Priority (A) Mode

Aperture-Priority mode is excellent for portraiture, landscapes, still lifes, and architecture as the depth of field can be easily controlled. Depth of field, a very important component in image composition, is controlled by the aperture setting. Aperture-

To use Aperture-Priority mode, set the exposure mode dial to A.

Priority (A) mode gives you the ability to select an aperture while the camera selects a corresponding shutter speed. To select Aperture-Priority mode, turn the exposure mode dial so that the A aligns with the index on the camera.

Even though the aperture can be selected on the lens, with D-type lenses the smallest aperture (the largest f/number, engraved in orange) must be set. It does not have to be locked, however locking is the best protection against inadvertent changes. With D-type lenses, if the smallest aperture is not set, the FEE error message appears on the LCD panel and in the viewfinder and the shutter release locks, preventing exposures from being made.

The aperture is selected in 1/2-stop increments by using the command dial. Unlike in Manual mode, you do not have to press the aperture button to set the aperture. The camera automatically selects a corresponding shutter speed for proper exposure, between 1/2000 second and 30 seconds. The selected settings appear in the viewfinder and on the LCD panel.

Since the shutter speed range is substantially larger than the aperture range, incorrect exposures do not often happen in A mode. But the camera could select a very long shutter speed, which increases the probability of camera shake. If LO appears in the viewfinder and on the LCD panel, the camera's slowest shutter speed is too fast for the selected aperture, however the shutter can be released, and the image will be underexposed. This can be prevented by selecting a larger aperture (smaller f/number) or by using flash (accessory or built-in), if the subject is within flash range. If flash is used, the exposure will be taken with the selected aperture and a sync speed of 1/125 second.

If the scene is too bright for the selected aperture and the camera's fastest shutter speed of 1/2000 second, HI appears in the viewfinder and on the LCD panel. The camera will allow you to make the exposure, however it will be overexposed. In order to prevent this, select a smaller aperture (larger f/number) until HI disappears. And if even this is not enough, try using a neutral-density filter.

The Nikon N60/F60's default settings in Aperture-Priority mode are 3D matrix metering with D-type, AF-S, and AF-I lenses, 6 segment matrix metering with other AF lenses, Auto-Servo autofocus, and single-frame advance. Exposure compensation, autoexposure lock with center-weighted average metering, and all flash modes are also possible.

Matrix metering delivers correct exposures under normal lighting conditions and for subjects with moderate contrast. Subjects with high contrast or strong backlighting require exposure compensation or autoexposure lock with center-weighted average metering. Substitute metering can also be helpful. Center-weighted average metering performs well when taking portraits in front of a very light or very dark background.

In Aperture-Priority mode you can select the exact aperture you need. Here, an aperture of f/32 was used to capture the columns in both the foreground and the background in sharp focus. The hyperfocal distance was also set.

Aperture vs. f/number

The aperture is the opening in the lens that allows a beam of light to pass through to the film plane. However, depending on the position of the diaphragm (the mechanism that creates the aperture) within the lens barrel, the beam of light will have a different diameter. Therefore in order to ensure a consistent standard of light measurement, the term "effective aperture" is used to define the size of a beam of light as a constant, regardless of the actual diameter of the aperture or the location of the diaphragm within the lens. The term aperture is often inaccurately used to mean f/number, while it is really only a mechanical device that limits the amount of light passing through the lens.

The f/number, or relative aperture, is expressed as a ratio of the lens' focal length to the diameter of the effective aperture (light beam). An aperture of 1:4 means that the focal length is four times greater than the effective aperture. The focal length-to-aperture ratio of 1:4 is expressed by the f/number 4 (f/4). Likewise, the focal length-to-aperture ratio of 1:8 is expressed by f/number 8 (f/8). This means that a smaller ratio is expressed by a larger number. Hence, the smaller the aperture, the larger the f/number and vice versa.

Manual Exposure (M) Mode

Manual exposure control requires some understanding of the principles of photography, such as the relationship between shutter speed and aperture. In Manual (M) mode, the exposure is determined entirely by the photographer. Unlimited selection

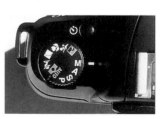

of the aperture and shutter speed, perhaps combined with manual focusing, allows the photographer to handle problems like backlight, low-key or high-key shots, exposure bracketing, experimental photography, photography with special-effects filters, as well as infrared photography. Long time exposures are also possible in Manual mode.

To use Manual exposure mode, set the exposure mode dial to M.

Photographing subjects behind glass can be tricky. The reflections on the glass cause difficulty not only for a camera's autofocus system, but also for its metering system. In order to have full control over the exposure, Manual mode is the mode to use.

To activate this mode, turn the exposure mode dial so that the M aligns with the index mark on the camera. If an AF lens is mounted, it must be set to the lens' smallest aperture (largest f/number), otherwise "FEE" will blink in the LCD panel and the shutter will lock. Touching the shutter release activates autofocus, and the exposure values last selected in M, A, or S mode (whichever mode was last used) appear in the viewfinder and on the LCD panel. The photographer can then set the desired shutter speed and aperture starting from those values.

Note: When lenses without a CPU (such as non-AF, shift, or mirror Nikkor lenses) are used with this camera, you must use Manual mode as the meter is disabled. The aperture must be set with the lens' aperture ring. No autoexposure mode will operate without a CPU in the lens.

To set the shutter speed in 1/2 stops, simply turn the command dial. To set the aperture in 1/2 stops, press the aperture button

while turning the command dial. The shutter speed and aperture settings will appear in the viewfinder and LCD displays.

Manual exposure mode uses Auto-Servo autofocus and single-frame advance. It is presumed in Manual mode that you want to control exposure of a certain area of the image, therefore its default metering system is center-weighted average. Auto-exposure lock and exposure compensation are also available, but as you have ultimate control over the exposure in M mode, it is likely they will rarely be used.

Once exposure has been set, deviations are shown on the exposure compensation scale in the viewfinder for the photographer's reference. The analog scale's 0 position corresponds to a correct exposure within a tolerance of +/–0.5 EV. To the left and right of the 0 are + and – symbols indicating over- or underexposure, respectively, within a range of 0.5 and 1.5 EV. (The indicators on this scale use different increments in Manual exposure mode than when it is used to indicate exposure compensation.) This relatively wide range of tolerance is not an issue with negative films, however with slide films, a deviation of 0.5 EV will be evident in the picture (the image may be slightly lighter or darker than intended). If the exposure you have set produces a reading on this scale other than 0, you can change the aperture or shutter speed to match the camera's "correct" exposure settings, or you can use the information to verify that the special exposure you have set deviates the correct amount from the meter's reading.

Long Time Exposures

Often nighttime scenes and special effects require exposure times that last longer than the camera's longest programmable shutter speed of 30 seconds. If that is the case, place the camera on a tripod and set it to Manual mode. Turn the command dial until "- -" appears in the shutter speed field of the viewfinder and LCD panel. (It comes after the 30-second shutter speed.) Set the desired aperture and press the shutter release to begin the exposure. Use your watch or a stopwatch to time the exposure, and when it is time, press the shutter release again to close the shutter.

The N60/F60 has no mechanical setting, therefore battery drain does occur with long exposures. A maximum of a 15-hour

exposure is possible with fresh lithium batteries, less in cold temperatures.

Lightning and fireworks are subjects that no automatic exposure metering system can handle. Only experience will help get you the right exposure. Long time exposures are definitely in order to capture these difficult subjects. Here are some tips to get you started:

To shoot lightning at night, first mount your camera on a tripod and set it to Manual exposure mode. Set the lens to manual focus, and focus it at infinity. Then select the long time exposure setting, and press the shutter release. The shutter stays open until the shutter release is depressed a second time. All you have to do is wait until lightning strikes; the lightning makes the exposure.

For fireworks displays you can manually select a length of time for the shutter to be open—5 to 15 seconds generally suffice. After all, you can usually predict when the fireworks are about to go off. In both cases, whether lightning or fireworks, select the aperture that is suitable for the film speed: use a small aperture with high-speed films and a large aperture with slower films.

Vari-Program for Portraits

Professional portraits characteristically have a sharp subject in front of a blurred background. Anyone who understands the relationship between magnification ratio and aperture and how they pertain to depth of field is well prepared to take portraits of this kind in any mode. However the N60/F60's Portrait mode makes it simple to take professional-looking portraits.

The Portrait mode is active when the symbol of a woman's head on the exposure mode dial is aligned with the index on the camera. In order to limit the depth of field, Portrait mode's software is designed to favor large apertures (small f/numbers). As a result, the Nikon N60/F60 always picks the lens' largest possible aperture that corresponds to the fastest possible

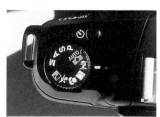

To set Portrait mode, set the exposure mode dial to the symbol of the woman's head.

shutter speed (1/2000 second). The aperture is closed down only if conditions are too bright for a 1/2000 second shutter speed.

The large aperture creates an effect in which the subject is sharp and the background is out of focus. This creates a distancing effect between the subject and background, making the subject pop. Portrait mode works best with fast 80mm lenses, however lenses or zooms with focal lengths between 80 and 135mm are also well suited to portraiture. Candid portraits shot from greater distances are best made with longer focal lengths between 180 and 200mm. However, the danger of camera shake is much greater with longer focal lengths.

In Portrait mode, the Nikon N60/F60 uses Auto-Servo autofocus, 3D matrix metering with D-type, AF-S, and AF-I lenses, 6-segment matrix metering with other AF lenses, and single-frame advance. Exposure compensation and slow sync flash are also possible.

If the Auto-Servo autofocus system detects subject motion, Continuous-Servo autofocus will become active. Continuous-Servo autofocus can be useful in creating "dynamic," active portraits (in which the head or body is in motion), particularly since fast shutter speeds, selected to correspond to large apertures, will freeze motion.

Classic portraits, however, are generally static poses often featuring an animated expression. An effective technique for natural expressions is to involve the subject in conversation, wait for the desired expression, and then fire. This is problematic if the red-eye reduction function is active because a few seconds pass between the time the shutter release is pressed and the exposure is actually made.

Portrait mode is programmed to set a large aperture so that the subject stands out sharply against a softer background.

The photographer can observe the subject's facial expression while looking through the viewfinder, but cannot react to an undesired change during the course of this operation. Paradoxically, the red-eye reduction function was designed specifically for portraits. If you are not confident that the shot you have taken was successful, simply try again.

If there is a great deal of difference in brightness between the foreground and background, use autoexposure lock with center-weighted average metering. Focus on the subject and press the AE-L button, recompose the frame if necessary, and with the AE-L button pressed, release the shutter. The difference in contrast can also be reduced by using fill flash.

If you are photographing a face and using a long focal length to fill the frame, the nose may be in focus while the eyes are not. A standard rule of portraiture states that one should focus on the eyes. All you have to do is aim the AF sensor at the eyes and lock focus by holding the shutter release partway down. You can then take your time and select the desired composition.

Portrait mode can be used to shoot portraits using a long focal length to isolate the subject or using a shorter focal length to reveal the surrounding environment.

Vari-Program for Landscapes

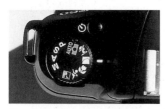

To set Landscape mode, turn the exposure mode dial to the mountain symbol.

Impressive landscape photographs usually feature an expansive view in which everything is in focus. Therefore, Landscape mode is programmed to be used with short focal length lenses and a narrow aperture to produce extensive depth of field. One could consider this mode to be the opposite of Portrait mode, which is designed to be used with longer lenses and produce narrow depth of field.

To select Landscape mode, turn the exposure mode dial until the mountain symbol lines up with the index on the camera. This mode's default functions are 3D matrix metering with D-type, AF-S, and AF-I lenses, 6-segment matrix metering with other AF lenses, single-frame advance, and Auto-Servo autofocus. Though the autofocus system will switch to Continuous-Servo if subject motion is discerned, you will hardly ever take a landscape shot that requires focus tracking! Because of the subject matter, there are many functions that are disabled in Landscape mode. The AF-assist illuminator is disabled as most landscape shots are taken at infinity, which is beyond the range of the AF-assist illuminator. Slow sync flash is also not possible in this mode. Red-eye reduction is available, but will probably not often be used. And as with all Vari-Programs, autoexposure lock with center-weighted average metering can be used, but again, with landscapes, chances are this will seldom be required.

Strongly backlit situations can be handled well in this mode. Take a substitute meter reading off the lawn or the palm of your hand and lock it by pressing the AE-L button. Then recompose the image and press the shutter release. This method can also be applied when using a wide-angle lens to take a picture with a large proportion of sky in the image.

Lenses and Landscape Mode
Short focal length lenses or zoom lenses at a wide-angle setting are most suitable for landscape shots. Lenses from 18 to 28mm

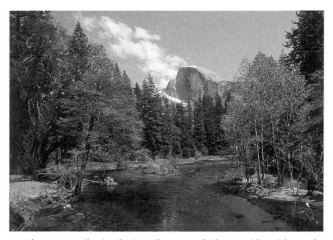

Landscape mode is designed to work best with wide-angle lenses. This photo was taken in Yosemite National Park with a 24mm lens. The Merced River is in the foreground and Half Dome can be seen in the distance.

by their very nature offer extended depth of field at their maximum aperture, and the depth of field expands as the lens is stopped down. This makes it possible to take a photo with both the foreground and background in focus. You can, of course, also use Landscape mode with 35mm to 50mm lenses. The wide-angle perspective decreases with an increase in focal length, but the images look more natural as the narrower angle of view corresponds more closely to that of the human eye. Landscape photographs can also be made with long telephoto lenses. In this case, focus on a detail within the scene, however care must be taken to guard against camera shake. (Shake-free shots with long lenses are more successful using Sport mode.) Landscape mode was generally designed to capture the overall scene.

Hint: Landscape mode is not intended to be used with telephoto lenses because it is programmed to select small apertures, making the shutter speed relatively long. This increases the probability of camera shake. A reliable rule of thumb is that if the shutter speed is slower than the inverse of the focal length of the lens, a sturdy tripod should be used.

This photo, taken in Arches National Park, was made using a 20mm lens. It has enormous depth of field, which is characteristic of shots taken in Landscape mode.

Taking Landscapes with a Foreground Subject

Using a wide-angle lens in Landscape mode does not limit you to taking wide-ranging vistas. You can also take scenic views with massive, impressive foreground subjects and distant, receding backgrounds. Lock focus or focus manually on the foreground subject, and since Landscape mode is biased to set a small aperture for extensive depth of field, you can be assured that the subject and background will all be in focus.

Vari-Program for Close-ups

Close-up mode is ideal for taking close-up or macro shots with limited depth of field. It performs best when used with specialized macro lenses (Micro Nikkors) or with zoom lenses set to their macro setting. To select Close-up mode, turn the exposure mode dial until the flower symbol lines up with the index on the camera.

Close-up and macro pho-tography are challenging for two reasons: An increase in magnification ratio usually results from extending the lens, which narrows the depth of field, making it

necessary to stop down the aperture to compensate. These two factors, the lens extension and stopping the lens down, lead to a loss of light, which in turn requires the use of longer shutter speeds. This is why the built-in flash is very important to this mode.

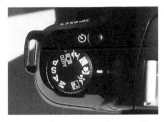

To use Close-up mode, set the exposure mode dial to the flower symbol.

Close-up mode is very similar to Portrait mode. However whereas Portrait mode sets the largest possible aperture, Close-up mode sets an aperture of f/5.6 whenever possible, and if lighting conditions require, it will set a smaller aperture to increase depth of field.

Fortunately at an aperture of f/5.6 shutter speeds are relatively fast, which is important for taking steady pictures. In situations where there is not enough light for a shake-free shot, you can mount the camera to a tripod, mount an accessory macro flash to the camera, or use the camera's built-in flash. Moving insects, for example, can be captured in sharp focus and with adequate depth of field when a flash is used. When using flash for macro shots, be aware that some very long lenses can project into the range of the flash beam and cast a shadow that falls within the image frame. See the N60/F60 owner's manual for specific lens-flash limitations.

Close-up mode uses 3D matrix metering with D-type, AF-S, and AF-I lenses, 6-segment matrix metering with other AF lenses, single-frame advance, and Auto-Servo autofocus. Neither exposure compensation nor slow sync flash are possible in this mode. The AF-assist illuminator is available for use when a long lens is used, increasing the distance that the autofocus system must reach. 3D matrix metering generally provides a balanced exposure between the main subject and the background.

When shooting stationary subjects in the macro range, use a tripod as it reduces the chances of camera shake.

Lenses and Close-up Mode
Zoom lenses with macro settings, such as the AF-Nikkor 24-50mm f/3.3-4.5D, 28-70mm f/3.5-4.5D, 28-85mm f/3.5-4.5,

The N60/F60's Close-up mode is designed for detail shots and small still lifes rather than true macro photography because an aperture of f/5.6 is almost always selected, which limits the depth of field at high magnification ratios. But for a shot like this, f/5.6 is appropriate.

35-70mm f/2.8D, 35-105mm f/3.5-4.5D, 35-135mm f/3.5-4.5, 70-210mm f/4-5.6D, and the 75-300mm f/4.5-5.6, can attain magnification ratios of up to 1:4 or 1:3.7. However the image quality of a lens optimized for infinity is significantly reduced in the close-up range. For high-quality macro shots, use true macro lenses such as the AF Micro Nikkor 60mm f/2.8D, AF Micro Nikkor 105mm f/2.8D, AF Micro Nikkor 200mm f/4D EDIF, or the AF Micro Nikkor 70-180mm f/4.5-5.6D ED. Also, be aware that long lenses and lens shades may obstruct the flash beam, affecting exposure.

How Deep Is the Depth of Field with Close-ups?

In the close-up range (the proximity required for a 1:1 reproduction), the depth of field is split 1/2 in front and 1/2 behind the plane of focus. With greater magnification ratios that surpass life size, the depth of field is divided 2/3 in front of the plane of focus and 1/3 behind it.

Vari-Program for Action Photographs

The N60/F60's Sport mode has a variety of uses. Sports photographs are generally taken at long focal lengths. This makes fast shutter speeds important for two reasons: first, to freeze motion, and second, to prevent camera shake. Sport mode is therefore biased toward fast shutter speeds. Whenever the lighting conditions and the lens' maximum aperture allow, a shutter speed of 1/500 second is selected. Sport mode is the N60/F60's only mode that uses Continuous-Servo autofocus and continuous-frame advance. This makes it easier to follow moving subjects. But Sport mode is not intended solely for sporting events. Portraits of moving subjects or children playing can benefit from the fast shutter speeds and predictive focus tracking inherent in this mode, which are not traits of Portrait mode.

Sport mode is active when the runner symbol is aligned with the index on the camera. Its settings include Continuous-Servo auto-focus, 3D matrix metering with D-type, AF-S, and AF-I lenses, 6-segment matrix metering with other AF lenses, and continuous-frame advance. The Nikon N60/F60's predictive focus tracking system can follow the motion of the subject as long as the shutter release is held partway down. But it only works with subjects that are moving towards or away from the camera at a constant speed. It is not designed to track focus on subjects that are moving across the frame, at an angle to it, or changing speed. Continuous-frame advance is well suited to this mode, performing at a rate of one frame per second.

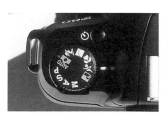

To set Sport mode, turn the exposure mode dial to the symbol of a running person.

The Sport mode is ideal for capturing any moving subject, especially children at play.

Flash is possible in Sport mode, however its practical use is limited. Instead of using the shutter speed of 1/500 second, which is standard for this mode in order to freeze motion, the flash forces the camera to set a sync speed of 1/125 second, which is usually too long to freeze fast-moving subjects. Also, sports subjects are often far away and out of the reach of the built-in

flash. One can, however, use flash creatively in Sport mode. Combining flash with a slow shutter speed (suitable to the speed of the subject) will produce a frozen subject with motion blur extending in front of the subject.

Good lighting conditions and a fast lens are prerequisites for Sport mode to be able to select fast shutter speeds. In poor light, slide films of ISO 200 to 400 can be used. When using negative films from which prints no larger than 8 x 10 inches (18 x 24 cm) are being made, you can use films with speeds up to ISO 800 or 1000 without too much loss of quality. In borderline cases, an image with a coarser grain and lower color saturation is preferable to an out-of-focus image. A sturdy tripod or a monopod (when heavy lenses are used) can reduce the danger of camera shake with longer focal lengths.

Panning Effects

Sport mode is designed to set fast shutter speeds that will freeze motion. But you can also pan the camera to capture the subject in focus while the background appears blurred. This can enhance the sense of motion in the picture and create a dynamic effect. Panning requires that you follow the subject with the camera by moving it at the same speed and in the same direction as the subject is moving.

The appropriate shutter speed depends on the speed of the subject and should be too long rather than too short. Therefore, if 1/500 second is too fast to get the effect you are after, use Shutter-Priority mode to select the actual shutter speed you want to use. If in doubt, select a shutter speed between 1/60 second and 1/15 second in Shutter-Priority or Manual mode (in Manual, don't forget to set an appropriate aperture). The effect you'll end up with is hard to determine while shooting, and your success rate will vary, so take several shots to be on the safe side.

Vari-Program for Night Photographs

The unique feature of the Night Scene mode is its slow sync flash function. It is particularly effective for photographing a person or subject in front of an illuminated skyline or sunset. With other modes you have two choices: either the main subject in the

To use Night Scene mode, set the exposure mode dial to the building-and-moon symbol.

foreground will be correctly exposed or the background will be correctly exposed. You will hardly ever achieve a balanced exposure in both the foreground and the background. Usually the subject will be correctly exposed but the background will appear too dark. However Night Scene mode selects shutter speeds slower than the normal flash sync speed (1/125 second), which ensures that the background is well exposed. The foreground subject is illuminated properly by the flash.

To select Night Scene mode, align the black building-and-moon symbol on the exposure mode dial with the index on the camera. The camera's built-in flash should always be popped up in this mode. (This does not happen automatically; it must be popped up manually by pressing the flash lock release button on the left side of the prism.) The AF-assist illuminator and Auto-Servo autofocus are available in this mode.

When Night Scene mode is active, the symbol for slow sync flash (lightning bolt with SLOW) automatically appears on the LCD panel. Standard flash synchronization is not possible. You can activate red-eye reduction by simultaneously pressing the flash sync mode button (marked with a lightning bolt) while turning the command dial until the eye symbol appears with a lightning bolt on the LCD panel.

Night Scene mode can be used with an accessory flash unit, and it is not restricted to any focal length range. You can experiment with any lens, but remember that shutter speeds are substantially slower in night shots when telephoto lenses are used. The shutter speeds required to correctly expose the background at night or dusk are so slow that the use of a sturdy tripod is recommended. If you do not have a tripod handy, a faster film (ISO 400 or 800) can help.

Reciprocity Effects

When using shutter speeds longer than 1 second, use of slow sync flash in Shutter-Priority (S) or Manual (M) mode is recommended. This is because shutter speeds longer than

The Night Scene mode is not limited to outdoor scenes, but can also be used to shoot large interiors such as this.

1 second can lead to reciprocity effects. Reciprocity effects can lead to either underexposure or color shifts. This requires an increase in the exposure value, either by selecting a longer shutter speed or a larger aperture. Exposure compensation of +1 EV, +2 EV, or +3 EV is also an option. Each film type has its

own reciprocity characteristics. The exact value of the adjustment required must be determined through experimentation as reciprocity effects are inconsistent and unpredictable.

It is possible that a film has different reciprocity characteristics within its various layers of emulsion. The data sheet accompanying each roll of film offers data concerning the reciprocity characteristics of that film type. However you will find data concerning only the amount by which the exposure has to be lengthened and nothing concerning color shift. Again, experimentation is the best solution.

Nikkor Lenses

In 35mm SLR photography, a lens is identified by two things: its focal length and its maximum aperture (or speed). A lens' angle of view (picture angle) is also of great importance as it is related directly to the focal length. In this chapter we'll discuss lens components and characteristics that will help you make informed decisions about determining which lenses are suitable to meet your photographic needs.

Focal Length

A lens' focal length is probably its most important specification. The focal length is engraved on the lens along with its maximum aperture (e.g., 85mm f/1.8). Focal length determines a lens' reproduction ratio, extension, and speed. Combined with the camera-to-subject distance,

Using the 24mm focal length from a "normal" point of view captures a broad view without exaggerating perspective.

the focal length determines how large an object will appear in the image. Lenses of identical focal length used from the same distance will record the same object the same size, regardless of the film format. For example, from a distance of 50 feet (15 meters), a 180mm lens records a particular object on film as 3/4 inch (19 mm) high regardless of whether the camera format is 35mm, 6 x 7 cm, or even 8 x 10 inches. The only difference is that as the format increases in size, more area surrounding the subject will be included in the image.

Reproduction ratio is also proportional to the lens' focal length. If the lens-to-subject distance remains the same, doubling the focal length doubles the reproduction ratio. So, if a 50mm lens records a certain object at a height of 1/2 inch (12.5 mm) from a given distance, a 100mm lens will record the same object at a height of 1 inch (25 mm), while the object shot with a 25mm lens will measure only 1/4 inch (6.5 mm). If you change from a 50mm lens to a 100mm, you double both the width and the height of the object's size on the image, quadrupling its size. Despite common belief, perspective is not determined by the focal length in any way.

Generally speaking, in 35mm photography a normal lens' focal length is approximately equal to the diagonal measurement of the film frame. Therefore, a 40mm to 60mm lens is generally considered "normal" (its film frame measuring 43.3mm); focal lengths of 35mm or less are considered wide-angles; and focal lengths longer than 70mm are considered telephotos.

Angle of View

A lens' angle of view, or picture angle, is a function of its focal length and the film format. In 35mm photography, a lens with a focal length of 21mm has a picture angle of 92°, while a 135mm lens has a picture angle of only 18°. Lenses with picture angles larger than about 50° are called wide-angles; those with picture angles smaller than about 40° are considered telephotos.

Lens Speed

Another characteristic of a lens is its "speed," or maximum aperture. A lens aperture is the opening in the diaphragm that allows light to pass through the lens to the film. Apertures are identified by f/numbers, which represent the ratio between the focal length of the lens and the diameter of the opening. If a lens with a focal length of 90mm has a maximum diaphragm diameter of 45mm, the aperture ratio is 90:45 or 2:1, hence the aperture is usually expressed as f/2.

A lens' speed is determined by its largest possible aperture. A small f/number means that the lens is capable of letting more light pass through to the film plane. A 50mm f/1.4 lens, for example, is "faster" than a 50mm f/1.7 by 1/2 stop.

Effective Aperture

Loss of light caused by absorption and reflection as light travels through the lens to the film plane inevitably reduces the effective aperture. In high-quality lenses, these losses are minimized by design, so the maximum aperture marked on the lens is also a good indication of its effective aperture. However, some lower-quality lenses can show a deviation between the two values of up to 1 full stop, so a lens with a marked maximum aperture of f/1.4 actually may have an effective aperture of f/1.9 or f/2. Cameras such as the N60/F60 with through-the-lens metering systems automatically compensate for these variations in light transmission.

Lens Components

Manufacturers' brochures usually contain technical data that can be helpful in evaluating a lens, such as number of elements, minimum focusing distance, minimum aperture, and filter size. Depending on the lens' intended use, some specifications may be of great importance, while others are of little meaning to a photographer.

Don't necessarily judge the quality of a lens by the number of elements and groups it contains. A lens designed with 16

elements in 12 groups may seem quite impressive, but the number of elements and groups actually gives little indication of image quality. The quality of the glass makes a difference.

The minimum focusing distance and maximum reproduction ratio are important specifications to know if you are shooting close-ups. Just because a lens is capable of rendering an image at a ratio of 1:5, it implies nothing about its performance at close distances. With the exception of true macro lenses, most lenses are designed so that their best image quality occurs when they are focused at infinity. Though a zoom lens might include "macro" in its name and have an extended focusing range, its forte is not precision close-up work.

The minimum aperture (largest f/number) indicates how far the diaphragm can be closed down to gain maximum depth of field at a given reproduction ratio. This is important to know if you are taking landscapes, close-ups, and other subjects that require extensive depth of field. There is however, one caveat to this: Particularly with short lenses, using apertures smaller than about f/8 reduces image quality due to refraction caused by the edges of the diaphragm blades.

Knowing the lens' filter size is helpful in purchasing filters with correct diameters. Ideally, all of your lenses should have the same thread size so that your filters are interchangeable on any lens, but this is not always possible. Other factors are far more important in choosing a lens, and filter size is seldom the deciding factor.

Other lens features include floating elements (which improve image quality at close range), internal focusing (which keeps the lens length constant while focusing), and a non-rotating front element (which maintains a fixed filter orientation during focusing). This information is sometimes omitted from the technical data, but it can be very relevant to evaluating a lens. Other specifications such as lens length, diameter, and weight are factors of great importance to travel, landscape, and nature photographers who have limited space and/or must carry equipment for extended periods.

Modern lenses for 35mm cameras are small masterpieces of precision optics, mechanics, and electronics. Built from hundreds of complex parts, they are produced and assembled to precise specifications. What follows are descriptions of the most

important components, which will help you make wise choices in selecting and handling your own lenses.

Bayonet mount: The bayonet mount is the link between a lens and the camera body. Both the bayonet on the lens and its mount on the camera must be machined to high accuracy in order to ensure that the lens axis is exactly perpendicular to the film plane. Perfect fit also ensures that both the camera's and lens' mechanical and electrical operations are supported by a properly functioning signal-transfer system.

Lens barrel: The lens barrel is a hollow cylinder made of metal or plastic in which the glass elements are precisely mounted, centered, and locked in the proper positions. The more accurate the centering, the higher the image quality is.

The barrel and the helicoid should both be constructed of materials that are insensitive to temperature variations. If both are made of materials with similar expansion coefficients, smooth and easy focusing will be ensured. The interior of the barrel, and every other internal structure, should be designed to absorb as much stray light as possible and coated with matte-black paint.

The torque required to turn the helicoid and move the lens barrel is important to the overall design of a lens. A straight in-and-out, push-pull movement of the lens barrel with a non-rotating front end facilitates the use of filters that require a specific orientation on the lens. Once set, their position and effect is unchanged while the lens is focused. However, some photographers prefer the feel and action of a rotating zoom barrel.

Diaphragm: The lens diaphragm is a mechanical device built into most 35mm-format lenses consisting of multiple crescent-shaped blades that produce a symmetrical opening (aperture) centered on the optical axis of the lens. Varying the size of the opening controls the amount of light entering the camera. Nikkor diaphragms are designed and built to close accurately and repeatedly to the

The aperture is created by the diaphragm blades.

predetermined diameter, thousands of times, at any temperature. The blades are designed to close quickly and arrive at each designated position with a minimum of bounce. Like the interior of the lens barrel, the diaphragm blades are black to suppress reflections and stray light.

Distance and Depth-of-Field Scales

To achieve sharp pictures, the image must be focused accurately on the film plane. Therefore, viewfinders of 35mm cameras offer various focusing aids such as a split-image rangefinder, matte Fresnel field, or electronic focus indicator. Whether set manually or by the AF system, the focusing distance, indicated in feet and in meters, can be read off a scale on the focusing ring. The distance position for infinity is represented by a symbol (∞), also marking the end of the helicoid's rear travel. (To allow for temperature-related variations, some telephoto lenses can be rotated beyond the infinity mark.)

The distance scale's most useful function is to allow the photographer to determine depth of field. Many lenses have a second scale engraved on their barrels, consisting of pairs of f/numbers situated symmetrically around an index mark. With the help of this scale, the photographer can discover the zone of sharpness resulting from a particular distance setting and aperture value. (See page 52.)

The same scale also permits you to set the hyperfocal distance, which gives the greatest possible depth of field for any given lens aperture. To do so, align the infinity mark on the focusing ring to the number on the depth-of-field scale corresponding to the desired f/stop. The total depth of field, as displayed on the focusing ring, extends from infinity to the distance shown by the corresponding f/number on the other side of the index mark.

Also found on some depth-of-field scales is an infrared focusing mark. Because infrared radiation focuses at a different distance than visible light, images shot with infrared film would be blurry if a focus adjustment were not made. To focus when shooting with infrared film, set focus visually looking through the focusing screen. Then align the focusing distance with the infrared focusing mark (usually a short line or dot) on the lens.

This should be considered only as a general reference point for infrared photography.

Autofocus Components

Regardless of the operating system, any autofocus (AF) system requires a motor to drive the helicoid in the lens. This AF motor can be situated in the camera body or the lens itself. Several zoom lenses offer motorized or "power" zooming, facilitated by a separate zoom motor. Many newly designed lenses are also fitted with a micro-computer chip responsible for the exchange of distance data between the camera and lens.

Focal Length and Perspective

One of the most important factors in image composition is the selection of focal length. This choice radically alters the "look" of your images based on the rules of perspective. In simple terms, perspective is the two-dimensional depiction of three-dimensional objects. Photographic perspective encompasses not just one subject, but numerous subjects of varying sizes and distances, anywhere in the three-dimensional space to be reproduced in an image. Despite common misconceptions, perspective is not determined by the lens but exclusively by camera location and subject distance.

The Rules of Perspective
The spatial illusion of three dimensions in photography is created according to the rules of central projection. This springs from two important concepts: *foreshortening and convergence.*

Foreshortening means that identically sized objects are pictured smaller as their distance from the camera increases—identical objects closer to the camera seem large, while more distant objects appear small. The effect is especially obvious at short camera-to-subject distances and is much less noticeable at long ones. That's why foreshortening is strongest in wide-angle shots that include clearly identifiable objects in the

20mm

24mm

35mm

50mm

70mm

100mm

135mm

200mm

300mm

These nine photographs illustrate the different views that various focal lengths achieve when shot from the same location.

foreground and in the background. A small stone, for instance, photographed with a 21mm wide-angle lens from 8 inches (20 cm) away may look like a boulder; likewise, a boulder in the distance will look like a pebble. This effect is very apparent in a full-face portrait made with a wide-angle lens, creating a caricature of the person, with a huge nose and distorted features.

Parallel lines that run diagonally through an image into the distance converge at a vanishing point outside of the image area.

The rules of central projection also determine the appearance of converging or "vanishing" lines, creating the illusion that parallel lines running along the lens axis meet at a single point. In effect, the lens becomes the center of perspective, equivalent to the human eye. This impression occurs when you photograph, for example, a set of railroad tracks. If the tracks run nearly vertical to the image (along the lens axis, straight away from

Parallel lines that run straight through an image into the distance converge at a vanishing point within the image area.

your eyepoint), they seem to converge in the distance. All parallel straight lines join at a single vanishing point created by perspective projection onto the flat image. This vanishing point, located exactly on the center of perspective, also determines the location of the horizon line.

The example of the railroad tracks reveals something more: The cross-ties on the tracks, aligned parallel to the image plane (and perpendicular to the lens axis), are depicted as parallel. In fact, straight lines running parallel to the image plane always remain parallel in photographs, because their vanishing points lie at infinity. This is true for vertical, horizontal, and inclined straight lines, as long as they are aligned parallel to the image plane—a characteristic that's vital to achieving a natural look in architectural photography.

Picture Angle and Perspective Distortion

One of the most important features of central projection is the faithful depiction of straight lines. Any well-corrected lens will reproduce a straight line straight, regardless of the focal length. (An exception is the fisheye lens, with its purposely uncorrected barrel distortion.)

A classic example of perspective distortion concerns the converging lines that occur when the image plane is tilted upward, for instance to capture a tall building. The same effect occurs when you photograph a building from a higher position shooting down, only the building walls appear to converge toward the base of the building. Such converging lines are nothing more than the familiar vanishing lines, transposed to the vertical plane. Imagine a set of railroad tracks running up the side of the building, and you'll get the idea.

Perspective distortion should not be confused with an optical defect that causes straight lines to be depicted as curves. That problem is the result of spherical aberration, often caused by a poorly placed lens diaphragm. Perspective distortion, on the other hand, is not an image defect and cannot be corrected by improving the lens design.

With ultra wide-angle lenses, you may notice that objects at the edges and corners of the image frame look distorted. Linear distortion of rectangular objects follows the rules of central projection. Therefore, a well-corrected wide-angle preserves the appearance of vanishing lines so that straight lines stay straight. The larger the picture angle, the steeper the angle of the vanishing lines. Round objects situated at the image's edge,

especially in the corner, are subject to elliptical distortion. This becomes more pronounced at increasing picture angles, near the edges and corners of the image. Both types of distortion are most noticeable at short camera-to-subject distances.

The distortion evident in this image is caused by the extreme angle of view of the ultra wide-angle lens.

Interchangeable Lenses and Perspective

As stated earlier, the composition and expression of your images are profoundly influenced by perspective. Contrary to common belief, perspective is determined exclusively by the camera's position in relation to the subject, not by the focal length or picture angle of the lens.

If you were to make an enlargement from a tiny portion of a wide-angle shot, its perspective would exactly match that of a telephoto image taken from the same location. As an experiment, shoot a subject with different focal lengths and change your

20mm

35mm

50mm

70mm

100mm

200mm

These six photos illustrate how the perspective changes with alterations to the camera-to-subject distance. The photographer changed his location to depict the subject the same size in every shot, however the change in perspective can clearly be seen.

position to keep the subject's size constant within the frame. The resulting photos will reveal the different perspectives that result from the changes in camera-to-subject distance, particularly in how the background is rendered.

A natural-looking, undistorted picture is best realized with a normal or medium telephoto lens that is not positioned very close to the subject. The main subject and its surroundings are rendered with correct shapes and relative sizes, and the vanishing point is back far enough so that perspective is not exaggerated. An eye-level camera position and film placement parallel to the subject also contribute to a natural appearance.

20mm focal length at 1 foot

100mm focal length at 3.3 feet

20mm focal length at 1 foot

100mm focal length at 4.3 feet

20mm focal length at 1.3 feet

100mm focal length at 8 feet

Here you can compare how a change in focal length from wide-angle to telephoto affected the depiction of the objects as well as how a change in distance affected perspective. Also note the difference in how round and angular objects were affected by those variables.

Conversely, the best way to achieve a strikingly dramatic depiction of a subject is to use a short focal length at close range. With a short focusing distance, the vanishing point is shifted toward the front, and the converging lines are quite steep. Everything near the camera is presented at an exaggerated size, while distant objects appear far too small. This unusual view can be further exaggerated by tilting the camera.

When choosing focal length and focusing distance, the shape of the subject is an important consideration. In the set of photos on page 116, an assortment of round and rectangular objects were taken with a 20mm wide-angle lens from a short distance and from a high angle. The objects, particularly those in the foreground, appear grossly distorted. The short focusing distance and high angle cause an exaggerated depiction of perspective slightly stretching, but not disfiguring, the objects. The photos are rather lively and create a sense of connection to the subjects.

In comparison, a set of photographs was taken of the same objects, pictured naturally, with a 100mm lens. The edges of the packs are nearly parallel, with only a trace of converging lines. This perspective seems realistic, if uninteresting. The 100mm shots do not display any noticeable sense of perspective, so they seem far more "normal" and are generally preferable.

These examples clearly indicate that there are no mandatory rules for making use of perspective. The aim is to achieve a visual effect that suits your concept of the image. Camera position and lens focal length should be chosen to create the desired perspective, not merely to crop out distracting details. You can always crop a print or a transparency, but perspective can only be created at the moment of exposure.

Interchangeable Lenses

Many photographers think of interchangeable lenses in very simple terms: If you can't move far enough away from a subject, use a wide-angle; if you're unable to get close enough, use a telephoto. This approach is a good starting point, but it is somewhat limited. It ignores the most important reason for choosing a focal length: to achieve the composition that you want. A telephoto lens is helpful in recording an object, animal, person

This photo taken in Monument Valley with a 24mm focal length gives strong emphasis to the foreground subject while including some visual texture in the background. This serves to draw the viewer into the picture.

or group from a discreet distance. A moderate wide-angle lens allows a subject to be shown in relation to his or her surroundings.

Lenses, Vision, and Composition

Photographic lenses "see" differently than the human eye. Our vision is three-dimensional, with a sense of depth that is actually created in the brain. A lens, on the other hand, sees only a two-dimensional image. The impression of depth must be created by the lighting effects, composition, depth of field, and perhaps by emphasizing the relationship between the foreground and the background.

To produce expressive images and fully exploit the opportunities that interchangeable lenses afford you, you need to become familiar with how each lens "sees," and its role in image composition. Longer focal lengths, with narrower picture angles, tend to isolate the subject from its surroundings and force the viewer to concentrate on the selected object. Such isolation can also emphasize a subject's details. On the other hand, an object that seems isolated to the human eye can be visually "connected" to its surroundings by employing a short focal length lens with a large angle of view. A normal lens used from a medium distance will usually make an object seem as natural and as similar to human vision as possible.

In many situations, wide-angle photos can have a dynamic appearance. Photos made with wide-angle lenses tend to show a large surrounding area, which accentuates the sense of depth. The main subject in the foreground is emphasized, and its proportions may be distorted. Meanwhile, objects in the background rapidly diminish in size.

With longer focal lengths, the visible area behind the main subject is compressed, and the appearance of depth is less

This image, taken with a 300mm telephoto spans the distance effortlessly, rendering the eroded stone with sharpness and clarity.

pronounced. Changing the camera position and the focal length results in varying impressions of depth and space in a picture. You can make the foreground appear to "move" closer to the background, even if both are absolutely stationary. Space seems to compress and, with very long focal lengths, the horizon may disappear from the frame. A sense of balance is created, as objects in the background appear larger and the foreground subject becomes less dominant.

It makes good sense to experiment with different focal lengths until you are thoroughly familiar with every lens you own. Try a variety of shooting positions and distances. Also, look for vertically oriented subjects, and become familiar with holding and using your camera in the vertical position.

Taking just one lens on a short photographic excursion can be a great help in getting to know its point of view. Try changing your distance to the subject, as well as the camera's position (by tilting the camera, crouching down, shooting from an elevated position, etc.). By concentrating on a single focal length, you learn how the lens affects composition and the sense of perspective, and how and when to use it so it is most effective.

It's also interesting to shoot the same subject with various focal lengths. When switching to a telephoto, try picking out details within a large subject, such as a landscape or city panorama, to

create different pictorial effects. This exercise will illustrate the relationship between focal length, camera position, perspective, and reproduction ratio. Work on it awhile, and you may discover a favorite focal length, which should yield some great photographs.

Choosing the Right Lens

Manufacturers offer hundreds of lenses for the 35mm format, making it difficult for the SLR photographer to select the right ones for his or her needs. To simplify the process, consider a few basic questions:

❑ Do you prefer fixed focal length lenses or zooms?
❑ How important is lens speed to the types of photographs you take?
❑ Which focal lengths would you use most frequently?
❑ Are there special lenses that can expand your picture-taking horizons?

Naturally, there is no universal answer to these questions, because each photographer's situation and demands are different. However, pondering the basic issues in relation to your own favorite subjects and style of shooting will help narrow your potential choices.

Zoom or Fixed Focal Length?
From year to year, zoom lenses continue to gain in popularity. The most obvious advantage of zooms is their added flexibility. While a prime (or fixed focal length) lens has only a single focal length, a zoom model covers a range of focal lengths (such as 35-80mm, 24-120mm, etc.), replacing several lenses at once. This allows a stepless choice of focal lengths, so you need only to zoom the lens to change the subject's framing.

It is not by chance that zoom lenses are so popular, and their practical advantages can not be overlooked. With a zoom, there is less need to change lenses and fewer lenses to carry around. In addition, while a zoom lens may cost more than a prime lens, it is considerably cheaper to purchase one zoom than the several fixed focal length lenses it replaces.

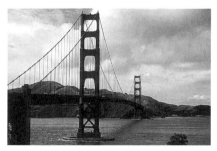

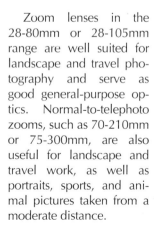

These five views illustrate the variety of effects you can achieve shooting with various focal lengths from various points of view. Each image has its own strength, demonstrating the versatility of 35mm SLR photography.

Zoom lenses in the 28-80mm or 28-105mm range are well suited for landscape and travel photography and serve as good general-purpose optics. Normal-to-telephoto zooms, such as 70-210mm or 75-300mm, are also useful for landscape and travel work, as well as portraits, sports, and animal pictures taken from a moderate distance.

The AF 24-120mm f/3.5-5.6D IF zoom is perfect all-in-one lens for travel photography.

Some photographers carry only one wide-range zoom that "does it all," such as a 28-200mm. This is certainly convenient, because you avoid the hassle of carrying and changing several lenses, and you are always ready for unexpected photo opportunities. On the other hand, wide-range zooms are generally larger and heavier than conventional short zooms, such as a 28-80mm. Even the new "ultra-compact" and "ultralight" models tend to weigh over a pound, considerably more than the typical normal or wide-angle lens.

Perhaps the biggest question still asked by countless photographers concerning zoom lenses is, "How does their image quality compare to that of fixed focal length lenses?" Today's zooms are comparable in optical quality to their prime focal length counterparts thanks to advances in the development of new types of glass, aspherical lens elements, computer-supported lens designs, and lens construction. In

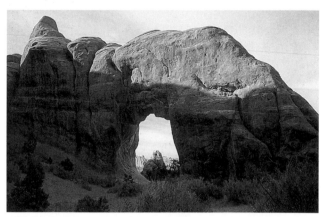

This landscape is typical of a view you could capture with a 20mm focal length.

comparing equivalent models, that is, middle-range zooms with middle-range fixed focal lengths, or high-power zooms with high-power fixed focal length lenses, you will find that prime lenses still offer image quality superior to that of zooms. Generally, the difference is most noticeable at the zooms' maximum focal length settings. In the case of zoom lenses covering a large range of focal lengths, such as 28-200mm, the best image quality is often achieved at the widest aperture.

At full aperture, zooms are generally inferior to fixed focal lengths, due to spherical aberration and the diaphragm's changing position. For average subjects at moderate settings such as f/8 or f/11, prime and zoom image quality tend to be roughly comparable, although a deterioration toward the edges of zoom pictures is still visible.

Available-light photographers should note that zooms tend to be slower than comparable prime lenses. Depending on the focal length, most zoom lenses have a maximum aperture between

With a zoom lens, you can quickly take a closer view by shifting to a 60mm focal length.

f/3.5 and f/5.6 because the design of many zooms includes numerous lens elements, causing a relatively large quantity of light to be absorbed.

The designations for zoom lenses often include a range spanning between two f/numbers. In order to keep zoom lenses as small and lightweight as possible, the maximum aperture varies with the change in focal length. The aperture is largest at the shortest focal length, then continually diminishes as the focal length is increased. This aperture variation is taken into account by the camera's TTL metering system.

Wide-angle to moderate-telephoto zooms often have rather limited close-focusing abilities. For example, a 28-200mm zoom may focus down to about 2.8 feet (0.9 meter). Although this may be acceptable at the telephoto end, it is certainly too long for a wide-angle, since it considerably restricts the possibility of emphasizing objects in the foreground against a vanishing horizon. A conventional 28mm lens focuses to about 1 foot (0.3 meter).

Each photographer must decide what features in a lens are important to his or her style of photography. Replacing several prime lenses with one zoom lens is appealing for any photographer wanting to travel light. Any slight loss of image quality may be irrelevant. Before deciding upon any lens, zoom or prime, every photographer should look at the individual lens' advantages or disadvantages in view of his or her favorite subjects, need for image quality, and individual way of working.

Lens Compatibility with the N60/F60

As mentioned previously, it is recommended that you use "D" lenses with the Nikon N60/F60 to take advantage of its full capabilities. You can also use older Nikkor lenses that have Automatic Indexing (AI) or those that have been AI modified. Lenses without a CPU can be used with the N60/F60, however automatic aperture and exposure information cannot be transferred to the camera, so the aperture and shutter speed must be set manually.

The following lenses are not compatible with the Nikon N60/F60 and will damage the camera and lens if mounting is attempted:

Non-AI lenses
AF Teleconverter TC-16A
400mm f/4.5 and 600mm f/5.6 with AU-1 focusing unit
6mm f/5.6 and 10mm f/5.6 OP Fisheyes
180-600mm f/8 ED (up to serial number 174166)
360-1200mm f/11 ED (up to serial number 174087)
200-600mm f/9.5 (up to serial number 300490)
80mm f/2.8, 200mm f/3.5, and Teleconverter TC-16 for F3AF
28mm f/4 PC (up to serial number 180900)
35mm f/2.8 PC (up to serial number 906200)
1000mm f/11 Reflex (serial numbers 142361 to 143000)
2000mm f/11 Reflex (up to serial number 200310)
Medical Nikkor 200mm f/5.6 (usable only with Sync Terminal Adapter AS-15)

Focal Lengths

Focal length is the most important attribute of any lens. Therefore, each of the following sections deals with a specific focal-length group and discusses the common characteristics of its members. Where necessary, the points of differentiation between individual lenses within a group are mentioned. Though Nikon offers a wide selection of manual focus lenses, only the Nikkor AF lenses are mentioned here.

Nikon has a wide range of manual lenses that can be used with the N60/F60, such as the Nikkor 13mm f/5.6. This lens' wide angle of view can open the door to infinite creative compositions.

Nikkor AF 18mm f/2.8D

Ultra Wide-Angle Lenses

The lenses in the wide-angle range (13mm to 21mm) have huge angles of coverage, ranging from 118° (13mm) to 92° (21mm). Nikon offers two ultra wide-angle lenses: AF 18mm f/2.8D and AF 20mm f/2.8D, with 100° and 94° angles of view, respectively. In addition, Nikon has one zoom within this focal length range, the Nikkor AF 20-35mm f/2.8D.

Originally used only for practical reasons when a photographer literally had his or her back against the wall, ultra-wides have become popular for aesthetic reasons. Extreme wide-angle lenses produce dramatic impressions of space. The foreground tends to dominate the picture, especially if the lens is close to the main subject, while the background appears to drift into the distance.

Nikkor AF 20-35mm f/2.8D

Ultra wide-angle lenses display extensive depth of field, even at their maximum aperture. Stopping down extends it even further, allowing everything from foreground to background to be pictured sharply.

Ultra wide-angle lenses are particularly well suited for architectural photography. Their large angle of coverage can allow multi-storied buildings to be depicted in their entirety, without converging lines, even from relatively short distances. Architectural pictures taken from a comparatively low position may include a lot of foreground, perhaps the surface of a street or a lawn. These features can often be made part of the composition. Also, converging lines can be used to create a dynamic sense of composition. Shooting from a "worm's-eye" view can emphasize perspective and exaggerate (or perhaps

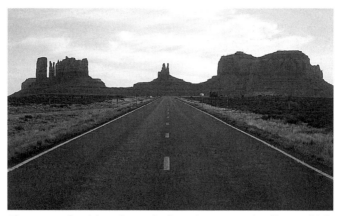

The 18mm focal length emphasizes the converging lines, which gives this image great depth.

even reverse) the size ratio in an architectural image. Experimenting with unconventional points of view can intensify the picture's impact.

Ultra wide-angle lenses pose specific challenges. In photos with dominant foregrounds, strongly tapering backgrounds, and wide, expansive horizons, composition can be difficult. The main subject must be carefully positioned, often in ways not dictated by the classic Rule of Thirds approach. And as the picture angle grows, a wealth of details may be revealed, including some unwanted ones. Often, this goes unnoticed until the image is projected or enlarged. So the viewfinder image should be thoroughly examined before shooting.

Simply trying to align the camera properly can be difficult as well. When shooting in small rooms, be sure not to accidentally tilt the camera. Also, direct flash is not likely to provide even illumination across the large picture angle, so bouncing the flash light off the ceiling may be necessary.

The varying levels of brightness and contrast you are likely to

Images made with a wide-angle lens typically demonstrate extensive depth of field.

This photo, taken with an 18mm lens, distorts the building's roof line according to the rule of central perspective.

encounter with so wide a field of view often creates a challenge for the camera's metering system. Careful light metering is particularly important in landscape shots made with ultra wide-angle lenses. Due to these lenses' extreme angles of coverage, the sky often occupies large parts of the image area. The resulting strong contrast between different sections of the image can mislead not only a center-weighted meter, but even the N60/F60's matrix meter, leading to an underexposed foreground. Depending on the contrast and the amount of sky included, an exposure correction of +1 to +2 stops may be necessary.

Vignetting and distortion are two of the ultra-wide's less-endearing properties. With vignetting, the greater the picture angle, the greater the darkening effect. Vignetting is most pronounced with the lens diaphragm wide open; closing down 2 stops usually reduces or even eliminates it. However, advanced design methods have minimized vignetting in today's better lenses. Distortion also increases with the picture angle, causing straight lines to be rendered as curves. In high-end ultra wide-angle lenses, distortion is usually well corrected and almost unnoticeable.

Telephoto lenses designated "ED" (Extra-low Dispersion) are particularly ▷ well corrected, offering excellent image quality as well as outstanding brilliance and sharpness. Always use a lens hood to prevent a telephoto's large front element from catching stray light that could appear in the photo as flare.

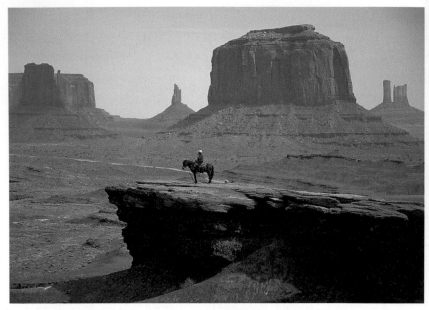

Zoom lenses are particularly useful for travel photography. They give you the flexibility of being able to take different compositions with a turn of the zoom ring, and you don't have to be weighted down with a full arsenal of single focal length lenses to cover every situation you might encounter. Here the photographer used a wide-angle setting of 24mm to photograph this Navajo chief overlooking Monument Valley.

The shot was taken with a 300mm focal length, which compressed the ⇨ distance between the foreground and background, yet separated the subject from his surroundings.

131

If natural-looking skin tones are desired, ISO 100 or ISO 400 films are the best choice. They have characteristically smooth gradation and understated color saturation, which produce very "pure" skin tones.

A running stream takes on a magical aura by shooting it with a long ⮕ shutter speed and a narrow aperture to create a sense of motion in the water and depth of field extending deep into the woods. Manual mode allowed the photographer to open up the exposure beneath the dense canopy. Photo ©B. Moose Peterson/WRP

The effectiveness of an image, particularly a still life, is often determined by its background. In this image the poppies are removed from any contextual relationship with their surroundings, turning them into abstract forms. This effect is produced by using black felt as a backdrop to absorb all stray ambient light and keeping the subject far away from the background to prevent shadows.

Page 135 top:
Unlike with the poppy image, the background in this image was ⇨ deliberately arranged to create atmosphere. The wine glass and cigar are inextricably connected to the Bordeaux bottles in the background. But the bottles are suggested in an out-of-focus blur, leaving the main subjects to be easily identified. In addition to controlling the depth of field by setting a wide aperture, it was necessary to mount the glass and the cigar on a sheet of glass placed some distance away from the wine bottles.

Page 135 bottom:
If a pictorial, painterly quality is not your goal, still lifes can also tell a story through sharpness and brilliance. Brilliance can generally be controlled with creative illumination. Optimal sharpness is produced by using a macro lens, because conventional lenses optimized for infinity offer lower image quality in the close-up range.

135

A standard zoom such as a 28-80mm is a perfect choice if you want to take along only one lens. Its fairly wide focal length of 28 is great for travel photography, and the 80mm focal length works well for details and shots of people. This image was made at 28mm with a polarizer attached.

Fisheye Lenses

Although they fall in the same range of focal lengths, ultra wide-angle lenses should not be confused with fisheye lenses, which are purposely designed to have barrel distortion, bending all horizontal and vertical lines that don't pass through the image center. Only the lines that fall

This traditional view was taken with a 13mm focal length.

exactly in the middle of the frame remain straight; the farther the lines are from the center of the image, the more curved they are. Also, flat surfaces, such as walls, are rendered with a dish shape. These lenses are especially suitable for landscape photography or experimental architectural work.

Nikkor fisheye lenses are available in 16mm and 18mm focal lengths. Nikon's AF 16mm f/2.8D fisheye has a 180° diagonal picture angle, with full-frame coverage. The effect is similar to a panorama, if there are no obvious straight lines to be distorted in the image. Great care should be taken not to include the tips of your shoes in fisheye pictures (this happens more easily than you might think). The AF 18mm f/2.8D has a 100° angle of view.

The same view was shot using a Nikkor 8mm f/2.8 fisheye lens.

An even more unusual perspective was achieved by the photographer lying on the ground, shooting upwards with the 8mm lens.

Moderate Wide-Angle Lenses

The moderate wide-angle range, from 24mm to 28mm, is a favorite because their relatively large picture angles (84° for the 24mm and 74° for the 28mm) give your pictures wide-angle

This snapshot taken with a 28mm lens has depth, which draws the viewer in, while still appearing natural.

coverage without unduly exaggerating perspective. If the camera is aligned carefully, images have a well-balanced, almost natural look, even though their angle of coverage is greater than that of concentrated human vision. However, if you tilt the camera or shoot from a low angle, perspective will be exaggerated.

Nikon has three prime moderate wide-angle lenses: AF 24mm f/2.8D, AF 28mm f/1.4D, and AF 28mm f/2.8D. It also offers a number of zooms that cover this range: AF 24-50mm f/3.3-4.5D, AF 24-120mm f/3.5-5.6D, AF 28-70mm f/3.5-4.5D, AF 28-80mm f/3.5-5.6D, AF 28-200mm f/3.5-5.6D IF, and the non-D AF 28-85mm f/3.5-4.5 (no distance information can be transferred to the N60/F60 with this lens).

Expansive depth of field and relatively fast apertures render the 24mm and 28mm lenses ideal for photojournalism. Landscapes, cityscapes, candids, and group portraits are other strong applications. They are also appropriate for indoor shots in available light.

Wide-Angle Lenses
For decades, 35mm lenses were the most popular wide-angles, mostly because they were the only ones sufficiently corrected for high optical quality. More recently, improvements in lens technology have made it possible to design well-corrected wide-angle lenses with broader angles of coverage.

With a picture angle of 62°, the 35mm lens covers a considerably larger area than a 50mm normal lens, yet tends to provide a relatively normal rendition of perspective. The depth of field is also greater than a normal lens, and the shorter, lighter lens reduces the risk of camera shake. These characteristics lend themselves to candid photography, photojournalism, landscapes, group portraits, and environmental portraits of individuals. In addition, still lifes of larger objects and nearby architectural details are the 35mm focal length's natural domain.

The 35mm focal length can be used to take full-length portraits of people without showing any distortion.

Nikon offers one 35mm AF lens, the AF 35mm f/2D, and many zooms that include the 35mm focal length: all zooms mentioned in the ultra and moderate wide-angle lens sections as well as the AF 35-70mm f/2.8D, 35-80mm f/4-5.6D, 35-105mm f/3.5-4.5D, and AF 35-135mm f/3.5-4.5 (non-D lens).

Normal Lenses

Lenses with a focal length of 50mm are considered "normal" lenses because of the relatively natural view they portray. As it happens, the 46° angle of view of a 50mm lens is nearly identical to the angle of sight our eyes can see sharply. Nikon offers two normal lenses: AF 50mm f/1.4D and AF 50mm f/1.8 (non-D lens).

Nikkor AF 35-70mm f/2.8D

Nikkor AF 50mm f/1.4D

Normal lenses can be used in almost any area: journalism, candids, travel, still lifes of large objects, architectural details, posed portraits, and group shots. As a rule, normal lenses are compact, lightweight, and modestly priced.

Nikon's fast normal lens (f/1.4) is perfect for available-light photography at night or indoors.

Numerous zoom lenses include this focal length. Many photo dealers even offer a camera body packaged with a normal zoom, such as a 28-70mm, 28-80mm, 28-85mm, 35-70mm, or 35-105mm. If you don't purchase a kit, it's a good idea to start with a 50mm lens and branch out later when you discover which lens you want to add.

Moderate Telephoto Lenses

The focal lengths between 70mm and 135mm are the most popular in the telephoto range. Nikon has two prime lenses in this

range, the AF 85mm f/1.8D and AF 85mm f/1.4D. Zooms that cover this focal length range include: AF 35-135mm f/3.5-4.5, AF 70-210mm f/4-5.6D, AF 70-300mm f/4-5.6D ED, AF 75-300mm f/4.5-5.6, AF 80-200mm f/4-5.6D, and AF 80-200mm f/2.8D EDIF. Prime lenses or zooms of this type are easy to handle and very versatile. In fact, moderate telephotos are comparatively simple to

Images that appear natural to our eye can be made with a 50mm lens.

The Nikkor AF 85mm f/1.4D is an ideal portrait lens.

design and often display excellent overall image quality. Their relatively narrow picture angle simplifies composition by concentrating on the main subject and eliminating extraneous surroundings. Compared to wide-angle and normal lenses (assuming the same camera-to-subject distance), moderate tele-photos include less subject matter in the scene at a larger reproduction ratio. Their shallow depth of field at wide apertures can be used to render the subject sharply against a soft background.

Snapshots made from long distances are best made with a telephoto lens.

Another advantage of moderate telephotos is their tendency to slightly compress the space within the object area. The effect is not as distinct as with longer focal lengths and thus appears more natural to the viewer. Also contributing to the natural impression is the fact that these lenses produce very little distortion, creating a very pleasing rendering of portrait subjects. In addition, format-filling head-and-shoulder shots are possible from moderate distances, allowing the photographer to work at a comfortable distance from the subject. These properties have made 80-100mm optics so popular for photos of people that they are often called portrait lenses.

These characteristics make moderate telephotos ideal for still lifes and for details of landscapes or buildings. Because they tend to be relatively compact and fast, hand-held shooting is easy. Appropriate uses include journalism, travel, fashion, and candids taken from a discreet distance.

Telephoto Lenses

Lenses with focal lengths between 180mm and 300mm are used from even greater distances and display distinct telephoto characteristics: compression of space, narrow angles of coverage, and shallow depth of field. In photographs taken from intermediate distances, relatively small objects will fill the frame. On the other hand, these focal lengths are not quite long enough to span great distances. Zoo animals, for instance, may fill the picture area, while those in the wild may not.

Telephotos are fine lenses for frame-filling landscapes, such as a mountain or a rock face. In architectural photography, distant details (for instance a gable) can be captured, or a row of houses compressed into a stack. Candid portraits or concert shots are also possible from considerable distances. Sports and wild animal photography often require still longer lenses, unless you want to include the surroundings as well.

The classic telephoto range includes the focal lengths 180mm (picture angle 14°) to 300mm (8°). Nikkor zooms covering this range include AF 70-210mm f/4-5.6D, AF 70-300mm f/4-5.6D ED, AF 75-300mm f/4.5-5.6, AF 80-200mm f/4-5.6D, and AF 80-200mm f/2.8D EDIF. Nikon offers three prime lenses in this range: AF 180mm f/2.8D EDIF, AF-S 300mm f/2.8D EDIF, and AF 300mm f/4 EDIF. At these focal lengths, hand-held shots are

Moderate telephotos are excellent portrait lenses.

best made at 1/500 second or higher if optimum image quality is required.

With the additional length of these lenses, great care should be taken to focus accurately and release the shutter without causing any vibration. Whenever possible, mount long telephotos on a sturdy professional tripod and lock the mirror up before each exposure. For sports and wildlife photography, a monopod is a good compromise.

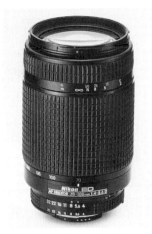

Extreme Telephoto Lenses
The most powerful lenses of all, extreme telephotos, with focal lengths between 400mm and

Nikkor AF 70-300mm f/4-5.6D ED

This photo demonstrates a typical characteristic of telephoto lenses— the compression of distance.

Telephotos are ideal for taking snapshots from great distances.

145

Nikkor AF 80-200mm f/2.8D

Nikkor 300mm f/2.8D EDIF AF-S

600mm (picture angle of 6° to 4°), are ideal for spanning long distances. They offer magnifications of 7x to 24x (compared with 50mm) and are well suited for wildlife, sports, and landscape photography. Because of the great shooting distances, perspective is extremely compressed, creating striking visual effects.

Nikon offers three extreme telephotos: AF-S 400mm f/2.8D EDIF, AF-S 500mm f/4D EDIF, and AF-S 600mm f/4D EDIF. Thanks to an internal-focusing design, they offer smooth manual focusing and autofocus.

We don't recommend handholding such long lenses, because even the slightest movement impedes their sharpness. Shoot from a sturdy, professional tripod and lock up the mirror whenever possible. And at high magnifications, even a tripod-mounted camera and lens may be affected by a strong breeze or by the movement of the mirror (if it was not locked up). Often a firmly held monopod can hold lenses up to 500mm more steadily than

Nikkor 600mm f/4D EDIF AF-S

a typical amateur tripod. However, avoid using a monopod on 600mm or longer lenses unless it is employed solely as a support for the lens barrel in addition to a sturdy professional tripod. Rather than using the tripod mount on the camera, be sure the one on the lens will facilitate easy changing between horizontal and vertical-format shooting. Also, using a lens hood protects the large front element from stray light and mechanical damage.

In addition to sports, telephoto lenses of 400mm to 600mm lenses are used for photographing animals in the wild or for landscapes where an important detail is to be isolated. These lenses can be used for fashion and advertising work as well, using their shallow depth of field and characteristic perspective to deliberately create striking effects.

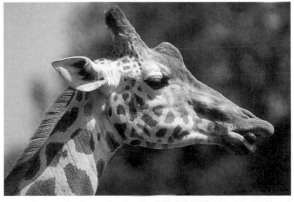

A 400mm telephoto is required for full-frame portraits of animals, even at the zoo!

147

Special-Purpose Lenses

Macro Lenses

Macro lenses are very versatile; they can either be used exactly like conventional models of the same focal length or as high-quality close-up lenses. Depending on the lens' design and focal length, reproduction ratios up to 1:2 (half size) or 1:1 (life size) can be achieved without extension accessories. Special close-up

Nikkor AF Micro 105mm f/2.8D

equipment, such as a bellows unit, close-up filter, or extension tube, enables you to achieve even greater magnifications.

Nikkor macro lenses include: AF Micro 60mm f/2.8D with a minimum focusing distance of 8-3/4 inches (21.9 cm) and a possible reproduction ratio of 1:1; AF Micro 105mm f/2.8D with a minimum focusing distance of 1 foot (31.4 cm) and a possible reproduction ratio of 1:1; AF Micro 200mm f/4D EDIF with a minimum focusing distance of 1.7 feet (0.5 meter) and a possible reproduction ratio of 1:2; and AF Micro 70-180mm f/4.5-5.6D ED with a minimum focusing distance of 1.4 feet (1 meter) and a possible reproduction ratio of 1:1.

The AF Micro 105mm f/2.8D was used to capture the precise detail in this cigar box lid.

Perspective Control (PC) Lenses

Shift lenses are specially designed to correct perspective distortion that is evident with subjects prone to converging lines, such as architecture. To achieve parallel perspective, you have to shift the lens' optical axis, which is easily accomplished with a perspective control (PC) lens. Nikon makes two shift lenses that can minimize this effect, the 28mm f/3.5 PC and the 35mm f/2.8 PC.

To achieve parallel perspective, first align the film plane with the front surface (the building's facade), then shift the lens axis to include the second surface (the building's side).

In an uncorrected photo, central projection causes the building's front and side to be depicted with distinct vanishing lines. In a corrected photo, the film plane is first aligned parallel to the facade, correcting the vertical perspective lines. Then the lens is shifted (perhaps 11mm to the right) to correct the horizontal perspective lines. In this way, the building takes on a more natural appearance.

This shot exhibits converging lines that result from the film plane and the building's face not being parallel.

This was taken from the same location, but it has no converging lines because the lens was shifted 10mm, allowing the film plane to be parallel with the building's face.

Parallel perspective is not helpful just for outdoor shots. For studio photographs of rectangular objects such as packages, books, or appliances, it creates a more natural look. These lenses make it possible for you to render a three-dimensional object on a two-dimensional surface just as you perceive it.

Mirror Lenses

Catadioptric, or "mirror" (also called "reflex") lenses are a special type of telephoto that uses a "folded" light path (the light is bent back and forth from mirror to mirror), which compresses a very long focal length in a surprisingly compact barrel. The light beam enters through a large, ring-shaped lens element and is reflected by the ring-shaped primary mirror onto a smaller, secondary mirror. This mirror then reflects the light back through the other lens elements onto the film.

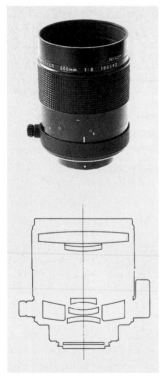

Nikkor 500mm f/8 Reflex

Due to its unique construction, a mirror lens cannot accommodate a variable diaphragm. The f/number noted on the lens is the only possible aperture setting. And because of the folding of the light path, mirror lenses are typically very slow.

Nikon offers three mirror lenses in their lineup: 500mm f/8, 1000mm f/11, and 2000mm f/11. While the slow speed may be problematic in some instances, these lenses are usually mounted on a tripod, which allows for slower shutter speeds. The most limiting feature of a mirror lens is that the fixed aperture gives the photographer no way to control depth of field.

Optical correction of these powerful telephotos is greatest at moderate-to-long distances, although some are capable of close focusing as well. For example, the Nikkor 500mm f/8 focuses to about 5 feet (1.5 meters) with a reproduction ratio of 1:2.5. The 1000mm f/11 focuses to about 25 feet (8 meters), and the 2000mm f/11 focuses to about 60 feet (18 meters).

Like all telephoto lenses used at long camera-to-subject distances, mirror optics give a distinct sense of flattening or spatial compression. Also unique to this design are "doughnut-shaped," out-of-focus highlights in the foreground or background, caused by the ring-shaped mirror and front element. Natural subjects for mirror lenses include travel and landscape photography (particularly for the 500mm focal length) and wild animals (with the 1000mm or 2000mm).

The circular highlights in the background of this image are caused by the ring-shaped mirrors in the reflex lens.

Teleconverters

Teleconverters extend the focal length and reduce the speed of the attached lens by a constant factor. Nikkor teleconverters TC-14A, TC-14B, and TC-14E increase the focal length by 1.4x, reducing the speed of the lens by 1 stop. Teleconverters TC-201, TC-301, and TC-20E increase the focal length of the attached lens by 2x, reducing its speed by 2 stops.

Each teleconverter is designed to be used with a specific family of lenses. The TC-14A is for use with short lenses whose rear element is flush, and the TC-14B is designed for use with lenses whose rear element is inset. The TC-201 is designed for use with lenses whose rear element protrudes, and the TC-301 with long lenses whose rear element is set in. The TC-14E and TC-20E are both designed for use with AF-I and AF-S lenses, maintaining all autofocus functions.

Aperture numbers and depth-of-field scales engraved on the lens are not valid with a teleconverter in place. If, for instance, an 85mm f/1.4 lens is turned into a 170mm f/2.8 by a 2x converter, the marked aperture of f/1.4 represents an effective opening of f/2.8 at the new focal length.

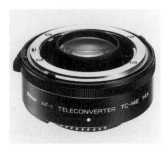

Nikon AF-I 1.4x Teleconverter TC-14-E

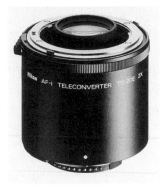

Nikon AF-I 2x Teleconverter TC-20E

A teleconverter not only increases the power of a telephoto lens, but its close-up capabilities as well. While the focal length with a 2x is doubled, the minimum focusing distance remains the same, resulting in a doubling of the reproduction ratio at a given distance. Optical quality does not match that of a true macro lens, but it is quite acceptable.

Converters are a good compromise for photographers who only rarely need the focal length achieved by using them. They offer a less-expensive alternative to purchasing a more powerful lens, for instance by converting a 400mm f/2.8 telephoto lens into an 800mm f/5.6. A traveling outfit can be kept small by replacing one or several focal lengths with teleconverters.

Flash Photography

Mastering the use of flash can add a new dimension to your photography. Flash can be used creatively to enhance image composition, to capture photographs under poor lighting conditions, or to even out contrast in a scene. The Nikon N60/F60 makes flash use easy.

The N60/F60 offers TTL flash control with either its built-in flash or a Nikon Speedlight when used with lenses containing a CPU (i.e., AF Nikkors). The matrix-controlled TTL exposure meter produces an exposure that is well balanced for both flash and ambient light, as ambient light is considered in the exposure calculation. With TTL flash you can also take photos in total darkness, in dimly lit rooms, or with backlit subjects. The camera determines the flash illumination—you do not have to worry about it. While it is easier than ever to take successful photos using flash with the Nikon N60/F60 automated systems, you will get best results if you take the time to read this chapter and experiment with the many different techniques and effects that are available to you.

Guide Numbers

While the N60/F60's sophisticated flash system determines exposure automatically, it is helpful to understand what guide numbers are. A guide number is a numerical value assigned to a flash unit by the manufacturer to quantify its maximum output. It is based on a mathematical formula involving the aperture and the flash distance:

Guide Number = Aperture x Distance

Guide numbers are usually determined using ISO 100 film as the standard. Since distance is part of the formula, guide numbers differ depending on whether they are expressed in meters or feet. Guide numbers used in the United States are expressed in feet (and therefore are 3.3 times larger than the corresponding metric

guide numbers), unless otherwise indicated. The flash unit's guide number can be used to calculate exposure for a given distance by using the same formula in a different way:

Guide Number ÷ Distance = Recommended Aperture

The higher the guide number, the more powerful the unit. Flash units are given a guide number by the manufacturer. When comparing two flash units' features, note the guide numbers and they will instantly tell you which is the more powerful unit.

The guide number depends on the film sensitivity and the reflector's angle of illumination. Remember, as the flash unit's zoom head position changes, so does its guide number.

Flash Synchronization

The Nikon N60/F60 is equipped with an electromagnetically controlled, vertically traveling focal plane shutter. A focal plane shutter has one characteristic that is critical in flash photography—during very short exposures the entire film frame is not exposed at once. This is because the slit that is formed by the two curtains traveling over the film frame is smaller than the film frame, and it sweeps over the film area exposing the frame in portions. If flash is used with a short exposure time, the flash will illuminate only that part of the film that is uncovered by the slit at the instant the flash goes off. The fastest shutter speed at which the entire frame is uncovered by the shutter curtains is called the "flash synchronization speed," which for the N60/F60 is 1/125 second. Any shutter speed slower than that will also expose the full film frame as the shutter blades expose the entire frame at once. However, using flash with shutter speeds faster than 1/125 second will not result in proper flash exposure of the entire film frame.

The Built-in Flash

Do not underestimate the Nikon N60/F60's built-in, pop-up flash! With a guide number of 49 in feet (15 in meters) at ISO 100, it is more powerful than most of the built-in flash units in comparable cameras made by other man-ufacturers. Not only that, but it is

designed to illuminate the angle of view of a 28mm lens! Nikon states that the recycle time to achieve a full charge is about 4 seconds.

When a lightning bolt symbol blinks on the right side of the viewfinder display, it is alerting you that flash is required in the current lighting conditions. If this should occur, raise the flash by pressing the flash lock release button on the left side of the prism. When the flash symbol in the viewfinder remains on without blinking, the flash is charged and ready to fire. After the picture has been taken (and your finger remains pressed on the shutter release), if the flash output was not adequate for proper exposure, or if the main subject was out of the flash unit's range, the flash symbol will blink for 3 to 4 seconds alerting you to try again. Shortening the distance between the camera and the subject will usually solve the problem.

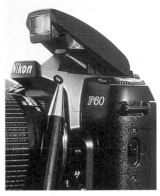

To pop up the camera's built-in flash, press the flash lock release button.

When the camera's flash is flipped up, it always fires when the shutter is released, no matter what mode it is in. When flash is no longer required, simply push it back down. The Nikon N60/F60's flash can be activated in any mode—even in Landscape or Sport modes in which flash would rarely be necessary. However, the choice of camera exposure mode determines which flash modes are available: normal sync, red-eye reduction, slow sync, or slow sync with red-eye reduction. More detailed information about using flash in these modes can be found on the following pages.

The built-in flash has a range of 2 to 35 feet (0.6 to 10.6 meters), depending on the aperture and film speed in use. This range is perfectly sufficient for portraits or candids. It is also adequate for illuminating statues or sculptures in churches or museums and for taking detail shots. If the built-in flash is too weak for a certain situation, you can either use faster film or mount a more powerful accessory flash unit. (The built-in flash cannot be used simultaneously with an accessory flash unit.)

Lenses and Flash Use

To fully utilize all flash functions that the N60/F60 has to offer, you must use lenses that have a CPU (AF Nikkors). With non-CPU lenses, only normal TTL flash mode is possible. Red-eye reduction and slow sync flash modes are not possible without a CPU in the lens.

As mentioned, the built-in flash is optimized for use with lenses starting at 28mm without a lens hood. Lenses up to 200mm as well as the Nikkor AF 300mm f/4 can also be used with the built-in flash.

Hint: Some lens hoods or certain focal length lenses may block a portion of the flash beam. To prevent this, play it safe by not using a lens hood when working with the built-in flash. A telltale sign of interference from the lens hood is a dark half-circle appearing at the bottom of the image.

The AF 20-35mm f/2.8 cannot be used successfully with the built-in flash as vignetting will occur. Also, the following lenses cannot be used with the built-in flash at focal lengths shorter than 35mm: AF 24-50mm f/3.3-4.5D, AF 24-120mm f/3.5-5.6D, AF 28-85mm f/3.5-4.5, AF 28-200mm f/3.5-5.6D IF. The AF 35-70mm f/2.8D cannot be used with the built-in flash at focal lengths shorter than 50mm. The AF 70-180mm f/4.5-5.6D Micro Nikkor should not be used at focal lengths shorter than 85mm.

Flash Displays

The flash symbols in the viewfinder and LCD panel operate with the built-in flash as well as with accessory Nikon system flash units. The flash symbol (lightning bolt) at the right of the viewfinder display has three functions: It blinks to alert you that flash is required for good exposure, it glows steadily when the flash is fully charged and ready to fire, and it blinks after an exposure has been made if the lighting was inadequate for proper exposure. The LCD panel displays the symbols for the various flash modes: red-eye reduction, slow sync flash with red-eye

reduction, and slow sync flash alone. These can be chosen by turning the command dial while pressing the flash sync mode button.

Flash Exposure Metering

A TTL (Through-the-Lens) flash metering sensor calculates the proper flash exposure. This, combined with the Nikon N60/F60's 6-segment matrix metering system for ambient light, produces the proper exposure for both flash and existing light in every exposure mode except Manual. Nikon terms this "matrix balanced fill flash."

In Manual exposure mode or when metering an exposure using the AE-L button, center-weighted average ambient light metering is used. In these cases the ambient light exposure and the flash output are calculated for whatever falls within the 12mm diameter metered area in the center of the image. (The 12mm etched circle in the center of the viewfinder screen receives 75 percent of the weight in the metering calculation.) When this is done, exposure for both flash and ambient light will generally not be as well balanced as with matrix balanced fill flash, and the effect of the flash may be more pronounced in the final image. For general photography of most common subjects, matrix balanced fill flash will produce more satisfactory results.

Matrix Balanced Fill Flash
The N60/F60's standard flash metering system, matrix balanced fill flash evaluates ambient light and the contrast relationship between various segments of the scene. This occurs before the flash is fired. The TTL flash sensor then controls the flash exposure. This means that confusing elements such as highly reflective surfaces or very dark areas are not considered by the flash sensor. This all takes place in an instant and produces uniform flash photographs in which both the foreground and background are properly illuminated. Depending on the subject, the flash illumination is controlled so carefully that the ambient lighting mood is preserved. Matrix balanced fill flash is used with the built-in flash as well as with Speedlight or Nikon-dedicated accessory flash units.

Matrix balanced fill flash can be used to fill in shadows when taking pictures on bright city sidewalks, in brilliant snow, or on the beach. When shooting indoors in available light mixed with flash, the Nikon N60/F60's matrix-balanced fill flash performs well, too.

Flash Modes

The Nikon N60/F60 offers four flash modes that can be used depending on the exposure mode in use: normal flash synchronization, red-eye reduction, slow sync flash, and red-eye reduction with slow sync flash. These individual flash modes can be selected by turning the command dial while pressing the flash sync mode button. The selected flash mode symbol is displayed on the LCD panel.

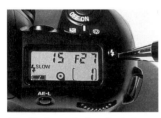

The flash mode is selected by pressing the flash sync mode button and turning the command dial until the desired mode appears on the LCD panel.

Normal Flash Synchronization Mode

Normal flash synchronization is the Nikon N60/F60's default setting in all exposure modes except Night Scene mode. When normal sync flash mode is active, no corresponding flash symbol appears on the LCD panel. Normal flash synchronization operates with matrix balanced fill flash in all exposure modes except Manual. In that case (or when the AE-L button is used), center-weighted average metering is the active camera metering mode. Normal sync flash is the ideal choice for flash photography of most standard subjects and situations.

Red-Eye Reduction Mode

Red-eye has ruined many a good portrait. The N60/F60 is equipped with a function that reduces the chance of red-eye, and it can be activated in any exposure mode (however only in conjunction with slow sync flash in Night Scene mode). To

activate red-eye reduction, press the flash sync mode button and turn the command dial until you see an eye symbol appear next to the flash symbol (lightning bolt) on the camera's LCD panel. Red-eye reduction is possible only when the camera's built-in flash is popped up or when an accessory flash unit is mounted and turned on.

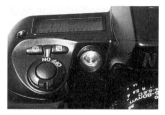

The lamp located between the hand grip and the prism is not only the AF-assist illuminator, but also the red-eye reduction light.

Red-eye reduction works as follows: When the shutter release is depressed, a lamp beside the camera grip sends out a beam of light for about a second. Then the shutter releases. This pre-flash reduces the chance of red-eye. The extent of the reduction depends upon several factors. Understanding them is the only way to control this undesirable occurrence with any certainty. A few basic explanations are therefore necessary.

The red-eye effect is the result of flash light being reflected off the blood vessels in the retina, back through wide-open pupils, and into the lens. The probability of this effect increases the shorter the distance is between the flash axis and the optical axis. The extent of the red-eye effect is also influenced by the direction the subject is looking, the nature of the subject's eyes, the flash-to-subject distance, and the focal length of the lens. Even the level of ambient light affects red-eye. When it is dark, the pupils dilate, which increases the effect and makes it very obvious. In red-eye reduction mode, the Nikon N60/F60 sends out a beam of light prior to the exposure, which is intended to close the pupils somewhat. This reduces the amount of reflection.

However, with that, there is a danger that the subjects' facial expressions can change in response to the bright light burst. To reduce this risk, warn your subjects that the red-eye reduction lamp will be going off so that it does not catch them by surprise.

Accessory flash heads are farther away from the lens axis than the camera's built-in flash, which means that red-eye is less likely to occur when they are used. Many accessory flash units offer the option of indirect flash—with a tilting or swiveling flash head so that light can be bounced off the ceiling or wall (see section on bounce flash, page 168). TTL control is maintained with all

Nikon-dedicated flash units. If the accessory flash has a red-eye reduction function, it overrides the camera's.

Slow Sync Flash Mode

In slow sync flash mode, the camera selects shutter speeds slower than 1/125 second (the standard sync speed in the other modes). This makes it possible to correctly illuminate both the main subject in the foreground and a dimly lit background. Slow sync flash is automatically set in Night Scene mode, but it can also be activated in Program and Aperture-Priority modes by pressing the flash sync mode button and turning the command dial until the word "SLOW" and a lightning bolt appear on the LCD panel. In Shutter-Priority and Manual exposure mode, selecting a slower shutter speed automatically results in slow sync flash. No flash mode symbol will appear on the LCD panel.

Slow Sync Flash Mode with Red-Eye Reduction

Slow sync flash can be combined with red-eye reduction mode. This is particularly effective for taking portraits in front of an illuminated building or sunset.

This combination can be selected only in modes that allow slow sync flash. In Night Scene, Program, and Aperture-Priority modes the LCD panel will display a lightning bolt, the word "SLOW," and an eye symbol. In Shutter-Priority and Manual exposure modes if a shutter speed slower than 1/125 has been selected, slow sync flash will be active, however only the lightning bolt and the eye symbol will be displayed.

Using Flash with the Camera in the General-Purpose and Vari-Program Modes

The simplest modes to take flash photographs in are the General-Purpose, Portrait, Close-up, and Night Scene modes. This is true whether the built-in camera flash unit or Nikon-system flash units are used with CPU-driven (AF Nikkor) lenses. The lens' smallest aperture (largest f/number) should always be locked to ensure that information is being transferred between lens and camera. Under poor lighting conditions, the flash symbol on the lower right of

the viewfinder will blink, indicating that flash is required. Flip up the built-in flash by pressing the flash lock release button, or turn on the mounted accessory flash and activate TTL mode. Red-eye reduction can be activated in any mode but is most suited to being used in Portrait mode.

Keep the following specifics in mind: The flash ready light (lightning bolt) in the viewfinder will glow steadily when the flash unit is fully charged and ready to fire. After firing, keep the shutter release depressed and check the flash ready light. Keeping the shutter release depressed keeps the metering system active, which illuminates the ready light, telling you when the flash is recharged or if the flash output was too weak for good exposure. When the flash is recharged and ready to fire, the ready light will glow

The N60/F60's matrix balanced fill flash automatically determines the correct amount of flash required to properly illuminate the subject.

continuously. But if the ready light blinks while the flash is recharging, it is telling you that the flash output was too weak or the main subject was outside the flash unit's range. If this occurs, try moving in closer to the subject.

Flash photography in "green" General-Purpose mode is recommended for photographic beginners and newcomers to SLR photography who are unreasonably afraid of using flash. Photographers who have no interest in technology will also find this mode very simple to use.

Use of flash makes sense in Portrait mode, particularly when used with red-eye reduction. Indoor portraits taken in candlelight or weak illumination are equally as good subjects as outdoor portraits made in the shade or with backlighting. Don't be overwhelmed with the technical aspects of trying to make your shots look "natural." Your first goal should be to avoid out-of-focus and incorrectly exposed shots. Nikon's matrix balanced fill flash will do what's necessary to select the correct flash output for most general situations.

Flash is also often required in the Close-up mode because the long lenses required in the close-up range swallow up a great deal of light. Small magnification ratios and short lenses can be used in conjunction with the camera's built-in flash. Larger magnification ratios and longer lenses can interfere with the built-in flash unit's illumination. A macro flash (such as the Nikon SB-21B) attached to the front of the lens with an adapter is recommended in such cases. The control unit is mounted in the hot shoe. The two flash tubes can be controlled individually to offer some level of lighting control.

The Nikon N60/F60 automatically uses slow sync flash mode in Night Scene exposure mode. If a person is in the foreground, you can also use the red-eye reduction feature. Night Scene mode makes it possible to correctly expose both the background and the flash-illuminated foreground. The camera should be mounted on a sturdy tripod in this mode to prevent camera shake. To minimize vibration, you can use the camera's self-timer to trigger the exposure.

Using Flash in Landscape and Sport Modes
Though it is possible to use the camera's built-in flash or an accessory flash unit in the Landscape or Sport modes, neither

would be used to its best advantage. Landscape mode is programmed for capturing far-reaching vistas, and subjects are generally outside the flash unit's range. The Sport mode is programmed to use fast shutter speeds, generally 1/500 second, in order to freeze movement. When flash is used, the shutter speed is automatically slowed to 1/125 second. With those limitations in mind, you may want to reconsider the mode you have selected if flash is important.

Using Flash with the Camera in Program (P) Mode

For great flash pictures without having to worry about technique, set the camera in Program mode—the camera makes all the decisions. Simply pop up the built-in flash or mount a Nikon-system flash unit to the camera, aim at the subject, and press the shutter release. Popping the flash up starts the flash charging automatically, and by the time you look into the viewfinder it is ready to use. To be sure it is charged before the exposure is made, press the shutter release partway, and glance at the flash ready light on the right side of the viewfinder display. If it glows steadily, the flash is charged and ready to fire. (This also occurs with Nikon-system flash units, as long as they are set to TTL

Taking flash photographs with Program mode is easy. Just pop up the flash, aim, and shoot.

mode.) In Program mode the Nikon N60/F60 always selects the camera sync speed of 1/125 second, and the aperture is selected automatically.

All four of the N60/F60's flash modes can be used in Program mode. However, flash cannot be used with Flexible Program (Program Shift). As soon as the built-in flash is flipped up or an accessory flash is turned on, a shifted exposure setting reverts to the normal exposure setting determined by Program mode.

Flash can be used with exposure compensation in Program mode. Setting exposure compensation on the camera affects the ambient light exposure and not the flash exposure. Flash exposure compensation can be set only on some Speedlight flash units specifically designed with that feature; it cannot be set on the camera. Flash exposure compensation affects the flash output but not the ambient (background) exposure.

Using Flash with the Camera in Shutter-Priority (S) Mode

You have to do a bit more work to obtain good flash exposures in Shutter-Priority mode than in Program mode—you must select the desired shutter speed. This can be done either before or after flipping the camera's built-in flash up or turning an accessory flash unit on. All shutter speeds between 1/125 second and 30 seconds can be used to synchronize with flash and can be selected in 1/2-stop increments. If a speed faster than 1/125 second is selected, the camera automatically switches to 1/125 second once the flash is charged and ready. This is true with both the built-in flash and system-compatible accessory flash units. The best aperture for the selected shutter speed and the ambient lighting conditions is set automatically. Both aperture and shutter speed can be easily read off the LCD panel or the viewfinder display.

Exposure compensation of the ambient light exposure is possible in Shutter-Priority mode, just as in Program mode. The only difference is that the aperture can be adjusted in 1/2-stop increments. Flash exposure compensation is possible only if the Nikon-dedicated accessory flash has that capability.

Shutter-Priority mode is a good choice if you wish to choose shutter speeds longer than 1/125 second. Unlike the Night Scene mode, Shutter-Priority mode gives you the freedom to control the background exposure by freely selecting the shutter speed as long as it is no faster than 1/125 second. Say, for example, you are photographing a person at dusk in front of an illuminated building on a city street. Traditional TTL exposure control would expose the person correctly while rendering the background black. While Night Scene mode creates a compromise exposure balancing the ambient background exposure and the subject's flash exposure, Shutter-Priority mode allows you to control the background exposure by selecting the shutter speed. If you want to do this very precisely, you can even take a separate meter reading of the ambient light and set the shutter speed according to the "expected" flash aperture. However, you should take two things into consideration: camera shake, which is always an issue even with a flash exposure (use of a tripod is recommended); and flash-to-subject distance—the main subject must be within the flash unit's range.

Dragging the Shutter
Photographs in which the subject is sharp but its edges are blurred can be made with the N60/F60 by selecting a relatively long shutter speed (e.g., 1/30, 1/15, or 1/8 second). This technique, called "dragging the shutter," is a pleasing way to convey energy or motion. By moving the camera slightly, you can also make the background blur, and by keeping the camera still and having the subject move you can keep the background sharp while adding a little more blur to the edges of the subject. Flash output is determined by the N60/F60's TTL flash control. To achieve optimal success with this technique you need to take time to experiment and refine your technique.

Note: Because the Nikon N60/F60 does not offer a second-curtain sync feature, motion blurs will not trail naturally behind the subject. The only way to achieve a trailing effect is to have the subject move in reverse during the flash photograph.

Using Flash with the Camera in Aperture-Priority (A) Mode

Flash photography with the camera in Aperture-Priority mode enables the photographer to control depth of field in the image by selecting the aperture. However, choosing an aperture also affects the range of the flash. The camera automatically selects a shutter speed of 1/125 second.

Even when flash is used, the aperture affects the depth of field. Here, a relatively large aperture of f/5.6 was used to separate the subject from the background.

All four of the Nikon N60/F60's flash modes can be activated in Λ mode. This is true with either the built-in flash or with Nikon-dedicated flash units.

After pressing the shutter release partway to activate autofocus and the camera's metering system, the aperture can be selected in 1/2-stop increments by turning the command dial. The camera automatically selects a sync speed of 1/125 second. This "stubborn" insistence on 1/125 second has no negative effect on the subject's (the foreground) exposure, but it can lead to an underexposed background. This is because flash exposure is affected by the choice of aperture and the ambient light exposure by the shutter speed. If you are unsure as to whether the 1/125-second shutter speed will be sufficient to illuminate a dark background with the aperture you have selected, you would be better off leaving flash control to the Program mode. Selecting an aperture in Aperture-Priority mode is an excellent way to control the depth of field and flash range in normal lighting circumstances.

Again, take the time to experiment with this technique when results are not critical. Try several exposures in which you select the aperture and then shoot the same scene using Program mode and compare the difference in the results.

Using Flash with the Camera in Manual (M) Mode

Even though TTL flash control still automatically determines the flash output in Manual exposure mode, a little more experience is required than in other modes to get consistently good results. In M mode one can use the aperture and shutter speed as creative tools in image composition. In Manual exposure mode, any lens aperture and any shutter speed between 1/125 second and 30 seconds can be selected in 1/2-stop increments. If a faster shutter speed is selected, the Nikon N60/F60 automatically switches down to the fastest flash sync speed of 1/125 second to ensure a full-frame flash exposure. The shutter speed is set by turning the command dial, and the aperture is selected by pressing the aperture button while turning the command dial.

In TTL flash control, the flash output is selected automatically according to the aperture selected. The ambient exposure is

determined by the shutter speed in use. Being able to select many combinations of aperture and shutter speed in Manual mode gives you control over the balance between ambient and flash illumination. This is very important if a natural lighting or creative effect is desired. Consider a simple example. You want to capture a room interior as well as the view outside the window in full detail. Any conventional TTL auto mode would expose the room correctly while letting the outdoor scene go dark. If you set your exposure for the outside view, the room will be too darkly exposed. What do you do? If you want to preserve the natural appearance of the scene, the outdoor scene must appear slightly brighter than the interior. Careful metering of the window light and the use of a hand-held flash meter, along with an accessory Speedlight with manual flash control would probably yield the best results. With a little bit of experience and by bracketing the exposure, you can achieve the final look you desire.

Flash photography in Manual exposure mode also offers a range of creative opportunities that can be achieved with long exposure times. One example is creating panning effects with a sharp main subject in front of a blurred background. Shots of a moving subject with a frozen center and blurred edges can be achieved in this mode (see page 165). The long time exposure setting in Manual mode can also be used with flash.

Bounce Flash

Direct flash often results in harsh lighting and severe shadows, which are not always desirable. Many accessory flash units offer the option of indirect or bounce flash as well. Some flash units are built with a tilting flash head; others offer both tilt and swivel controls for even more flexibility. With these kinds of flash units, the flash head can be aimed so that the flash burst does not hit the subject directly, but rather bounces off the ceiling or wall, which reflects onto the subject. This produces soft, even illumination with little or no shadow. When using bounce flash, make sure that the ceiling or wall that the flash is reflecting off of is a neutral color—preferably white—to avoid an off-color cast in the final image. TTL exposure metering remains active when bounce flash is used with Nikon-system flash units.

Reflectors and Diffusers

Many photographic manufacturers offer a wide variety of reflectors and diffusers for use with accessory flash units. Reflectors and diffusers soften the flash illumination, thereby softening shadows. They come in every shape and size and are generally attached to the flash using hook-and-loop fasteners such as Velcro®. Inflatable softboxes are available in a variety of sizes. They are ideal for portraits and still lifes. These accessories have no effect on TTL control when attached to a Nikon-dedicated flash.

A reflector such as this fill flap softens the light of an accessory flash unit.

Nikon Accessory Flash Units

Nikon makes Speedlight flash units in every size, weight, power, and price category to suit almost any application. They can be used with the Nikon N60/F60 if the built-in flash is not powerful enough or when specialized flash control or flash exposure compensation is required. An accessory flash unit can be mounted either on the camera's hot shoe or on a flash bracket. When an accessory flash is mounted directly on the camera, the built-in flash cannot be used.

Accessory flash units can be used to perform the same tasks as the built-in flash. In addition, Speedlights, depending on the model, offer a variety of functions such as flash exposure compensation, wireless TTL flash control, bounce flash, zoom reflector, pre-flash, repeating flash, and/or high-speed flash. All Speedlight flash units can be controlled by using the camera's TTL module. The

The more recent Speedlight flash units offer flash exposure compensation. A compensation factor of –0.5 EV was used here so as not to overexpose the man in the foreground.

Nikon N60/F60's matrix balanced fill flash produces natural-looking shots by balancing ambient and flash illumination. Center-weighted average metering (active in Manual mode or when using the AE-L button) is also an option with accessory flash units. We will briefly discuss the possibilities and features of the individual flash units in the following pages.

Nikon Speedlight SB-28

The SB-28 is a powerful flash unit with excellent features. It boasts a motor-driven zoom head, which can be set to correspond to the angles of view of lenses between 24mm and 85mm. When the built-in, manually adjusted wide-angle diffuser is used, the illumination angle can be set to correspond to lenses with focal lengths from 18mm to 20mm. Its guide number is 138 in feet (42 in meters) at ISO 100 and with the zoom reflector set at 50mm. The flash head can be tilted (maximum –7° down and 90° up) and swiveled 180°. This makes bounce flash possible in almost any direction.

The test flash button is also the flash ready light. When the test flash button is pressed, the SB-28 measures the light reflected off the subject. To test the flash, switch from TTL to A mode.

The SB-28's repeating flash mode allows the photographer to select the frequency of flash bursts (up to 50 Hz) as well as the number of flashes per exposure (up to 90). The strobe function

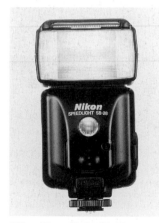

allows you to break down a subject's movement on one frame of film by exposing the moving subject multiple times without advancing the film. The best results of this strobe effect are obtained in darkness or in front of a dark background.

Flash exposure compensation, manual flash output control, and the AF-illuminator can also be used when the SB-28 is combined with the Nikon N60/F60.

Nikon Speedlight SB-28

Nikon Speedlight SB-27

The SB-27 is a compact and lightweight flash unit with a guide number of 112 in feet (34 in meters) at ISO 100 with the reflector set at 50mm. The SB-27 is a horizontal-format flash that can be swiveled to a vertical format. It can even be swiveled 180° in an arc above the camera. In the

Nikon Speedlight SB-27

horizontal position, the flash head's zoom settings can be set to correspond with 24mm, 28mm, 35mm, and 50mm focal lengths. Positioned vertically, the zoom head can be set to correspond with 35mm, 50mm, and 70mm focal lengths. Matrix balanced fill flash, flash exposure compensation, the AF-illuminator, and manual flash control are possible when the SB-27 is used with the N60/F60. It has a pull-out bounce reflector with a diffusion filter for indirect flash. Depending on the position of the flash (oriented left or right horizontally over the camera), the bounce reflector can be located above or below the flash head. It can thus be used either to create catchlights with bounce flash or to provide flash illumination for close-ups.

A small accessory flash unit such as the Speedlight SB-27 is handy for snapshots such as this.

Nikon Speedlight SB-26

The Speedlight SB-26 was introduced in 1994. The automatic zoom head has six click-stops that correspond to 24mm, 28mm, 35mm, 50mm, 70mm, and 85mm focal lengths. Using the built-in diffusion filter expands the flash angle to the angle of view of an 18mm or 20mm lens. In the 50mm position, the SB-26 has a guide number of 138 in feet (42 in meters) at ISO 100, and a guide number of 164 in feet (50 in meters) at 85mm. The flash reflector can be swiveled vertically (maximum –7° down, 90° up) and horizontally (90° to the right, 180° to the left), a feature that makes indirect flash an option.

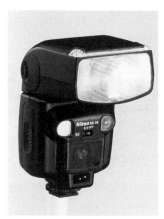

Nikon Speedlight SB-26

TTL control is fully maintained, even with bounce flash. The SB-26 has a test button, which allows you to determine if the flash output will be adequate in Automatic (non-TTL) flash mode without exposing the film. Strobe mode allows you to select the frequency (number of flash bursts per second, up to 50 Hz), the number of flash bursts per exposure (up to 90), and the level of output (1/8, 1/16, 1/32, 1/64 power). When it is used with the N60/F60, other functions are available, such as flash exposure compensation, manual flash mode, and the AF-illuminator. Unlike the SB-28, the SB-26 offers wireless remote capability. This enables you to trigger a second off-camera SB-26 while maintaining TTL control. Theoretically, any number of SB-26 flash units could be used. Regardless of the number of flash units used, wireless TTL control gives you the tools required to create professional lighting effects with the comfort of fully automatic control.

Nikon Speedlight SB-25

The powerful Speedlight SB-25 was released in 1992, with capabilities well suited to the technology of the N60/F60. Its flash head can be zoomed so that its angle of illumination matches the picture angle of 24mm to 85mm lenses. When the built-in

wide-angle diffuser is in place, it illuminates the angle of view of a 20mm focal length. The SB-25 has a guide number of 138 in feet (42 in meters) at ISO 100 when the reflector is in the 50mm position. AF-assist, matrix balanced fill flash, manual flash control, and strobe functions are all available with this unit.

Nikon Speedlight SB-24
The SB-24 is an older, but still powerful, flash from 1988. It offers matrix balanced fill flash, an AF-illuminator, and stroboscopic flash capability. The SB-24 has a moveable, motorized zoom reflector whose angle of illumination corresponds to 24mm to 85mm focal lengths. Even the output is respectable. It has a guide number of 138 in feet (42 in meters) at ISO 100 when the reflector is in the 50mm position.

Nikon Speedlight SB-23
The SB-23 is a compact flash unit with a guide number of 66 in feet (20 in meters) at ISO 100. It has a fixed flash head. Its power and features are so similar to those of the built-in flash that it does not make much sense to use it with the N60/F60.

Nikon Speedlights SB-22, SB-20, SB-16B, and SB-15
The SB-22, SB-20, SB-16B, and SB-15 are older-model flash units that can easily be used with the Nikon N60/F60 if you happen to already own one. Compared to the newer models, we do not recommend buying one of these on the used market, particularly since it is difficult to determine their condition before you buy.

Nikon Speedlight SB-22s
The SB-22s is a light, compact model from the latest generation of flash units and is an excellent option if the SB-26 and SB-28 are too big, too heavy, or too expensive for your needs. With a guide number of 92 in feet (28 in meters) at ISO 100, it is less powerful than other current Speedlights, with guide numbers of 138 in feet (42 in meters), but is

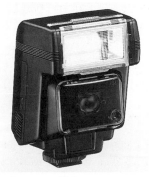

Nikon Speedlight SB-22s

more powerful than the camera's built-in flash. The flash head can be tilted down –7° and up 90°.

TTL Macro Speedlight SB-21B

This flash, designed for use in macro photography, is attached to the front of the lens. The adapter and control module is mounted in the Nikon N60/F60's hot shoe and attached to the flash unit by a cable. This flash unit consists of two parallel flash tubes that can be turned on individually for special lighting effects. The modeling light makes it easier to focus. Autofocus is possible only with the 60mm, 105mm, 200mm, and 70mm-180mm Micro Nikkor lenses. This is a wise investment for anyone specializing in macro photography.

Nikon Flash Accessories

In addition to the system-compatible flash units, Nikon offers a variety of flash accessories for the N60/F60.

SC-17 TTL Remote Cord

For using a flash off-camera or if a flash bracket is attached to the camera, an SC-17 TTL remote cord is required. The SC-17 is a 4.9 foot (1.5 meter) coiled cable with a flash connector on one end and a flash shoe with two multi-flash sockets on the other. The flash connector slides into the camera's hot shoe to relay information between camera and flash. The flash unit attaches to the shoe on the other end of the cord. Additional Nikon-system

TTL Remote Cord SC-17

flash units can be attached to the shoe by plugging TTL cables (SC-18 or SC-19) into the flash units and shoe sockets. The SC-17 allows all TTL flash functions to operate within the limits of what the camera offers.

SC-18 and SC-19 Multiflash Cords

The SC-18 and SC-19 are TTL extension cables with connectors on both ends for attaching Nikon multiflash system components (such as the SC-17 remote cord, multiflash adapter AS-10, and Nikon system flash units). Like the SC-17, these cords transmit all Nikon-system flash commands, maintaining full TTL compatibility between camera and flash unit. The two cords are identical except in length: the SC-18 is 5 feet (1.5 meters) long and the SC-19 is 10 feet (3 meters) long.

TTL Multiflash Sync Cord SC-18

TTL Multiflash Adapter AS-10

The multiflash adapter AS-10 allows you to mount one flash to its hot shoe and operate three off-camera flash units by connecting SC-18 or SC-19 multiflash cords to its sockets. It has a 1/4"-20 socket on the base for mounting it to a tripod or light stand.

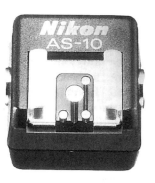

TTL Multiflash Adapter AS-10

Nikon SU-4 Wireless Flash Controller

Wireless Remote Flash Control Unit SU-4

Nikon offers a wireless remote flash control unit, the SU-4, for use with most recent Speedlight-series flash units (SB-15, 16B, 21B, 22, 22s, 23, 24, 25, 26, 27, and 28). Its infrared beam is used to trigger one, two, or more accessory flash units. One accessory flash is mounted in the SU-4's hot shoe. The camera's built-in flash or an accessory flash unit mounted to the N60/F60 can be used as the master flash control unit. The number of remote flash units and their positions determine the lighting effect. The SU-4 has a range of up to 23 feet (7 meters) in TTL Automatic flash mode and 131 feet (40 meters) in Manual flash mode.

Power Accessories

The Nikon external battery units SD-7 and SD-8 increase the flash capacity and reduce recycle times. This is basically also true of the SK-6 power bracket, which holds the flash to the side of the camera but can also be used off-camera. Various flash adapters, sync cords, and connecting cables for one or more flash units complete Nikon's flash lineup. If you would like to use your Nikon-system flash unit off-camera or on a bracket and retain its automatic functions, see your Nikon dealer, who will help you determine the best way to do this with your equipment.